A PASSION FOR SEA GLASS

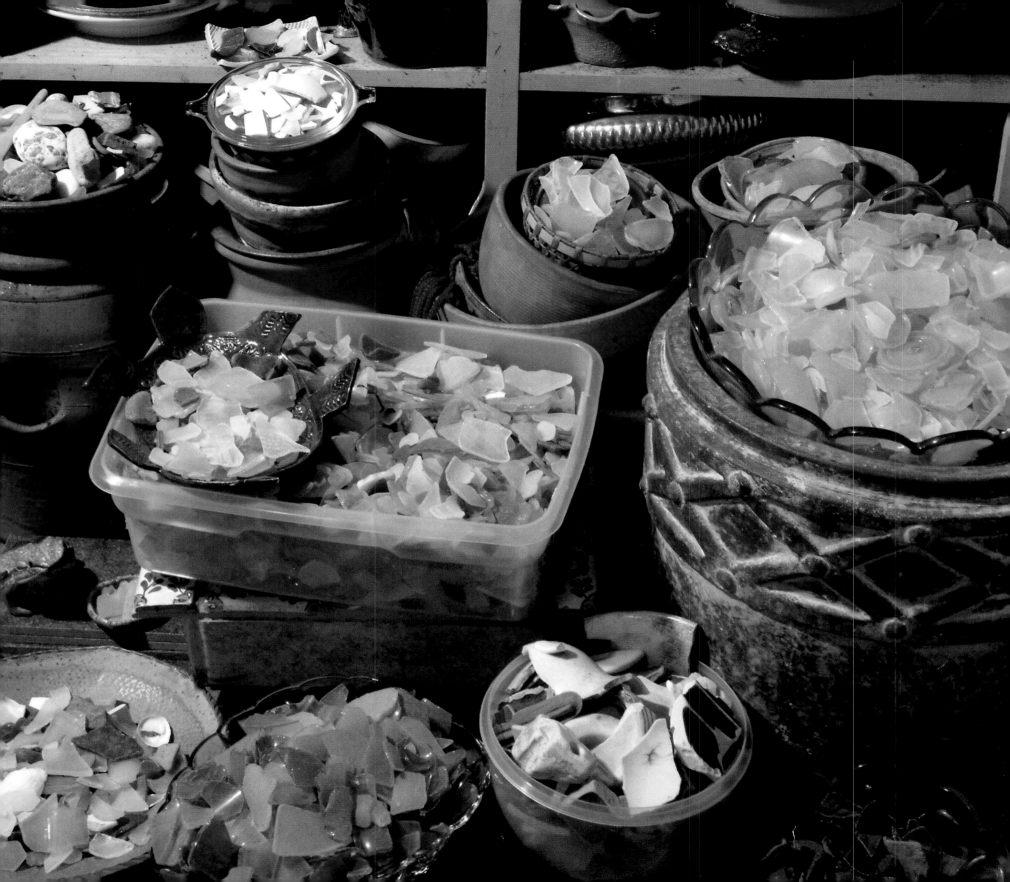

A PASSION FOR SEA GLASS

TEXT BY C. S. LAMBERT

PHOTOGRAPHS BY AMY A. WILTON

Down East

CONTENTS

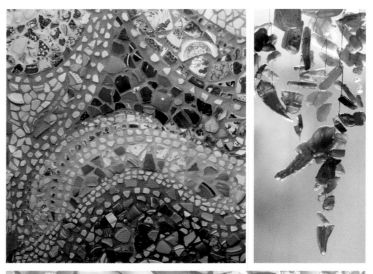

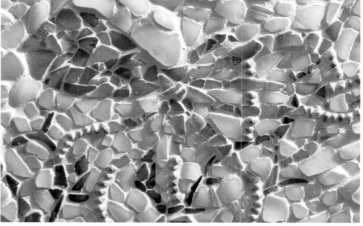

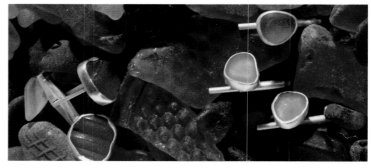

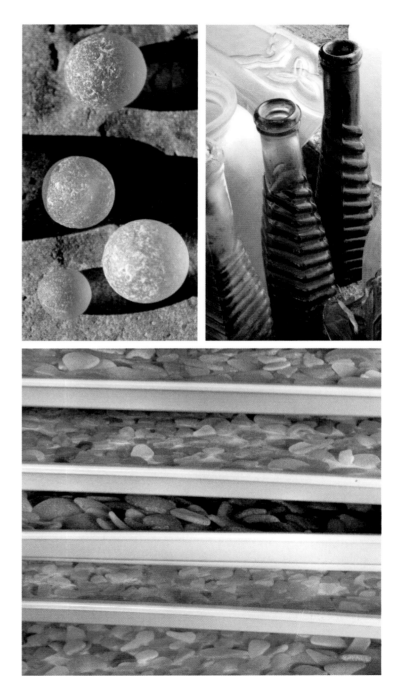

ACKNOWLEDGMENTS

Thanks to the following experts and friends for their generous contributions:
Gay Bogard, John Bottero, Chris Cornell, Christie Cummins, Ginger Dolham,
Pamela Dubin, Steve Dumas, Faith Hague, Su.Sane and Robert Hake,
Gary Harriman, Anthony Hutcheson at Right Click Computers, Linda Leonard,
Marty Martens, Sean McMinn, Laura Meade, Vivian Morosi, Neal Olson,
Sean Pinkham, Wyatt Shorey, Ian Summers, Neale Sweet, Joyce Tenneson,
Think Tank, Kaja Veilleux, Sandy Whitney, Emma and Nigel Wilton,
Marion and Bob Wilton, Karin Womer, and all the collectors in this book
who shared their passion.

PREFACE

Collectors from around the world have written to tell me that the general perception of collecting sea glass was elevated from *hobby* to *art form* with the publication of my first book, *Sea Glass Chronicles*, in 2001. Several mentioned that until then—even though hunting for sea glass was their favorite thing to do, even though they had amassed large quantities of glass and ceramic shards over the years, even though they considered it a happy obsession— many had kept quiet about what was often regarded as an odd or a useless pastime. Effectively, they said, they had been "outed" by *Sea Glass Chronicles* and they were grateful for it.

At the same time, especially at book signings and lectures, I was often asked by the uninitiated, "What do people do with sea glass?" "Why would anyone cherish objects that are essentially garbage?" and "Is there any value in these glass and ceramic fragments?"

In *A Passion for Sea Glass*, photographer Amy Wilton and I have attempted to answer these questions through our investigation into some of the most extraordinary collections in the United States. We soon realized that *why* was as important as *how* sea glass became integrated into their lives—physically, emotionally, intellectually.

A NOTE ON THE SELECTION

Certainly there are enough regions in the United States, not to mention the world, with large quantities of sea glass to merit several books on sea glass collections. In the end, I chose New England as a focal point, adding a few collections from outside the region. The criteria for inclusion in the book were simple: the collector is passionate about sea glass; the collection is prominent in home or workplace; sea glass has a definable meaning to the collector.

No doubt some readers will be disappointed that I chose against naming specific beaches and, in some cases, the location of the collections. I have done this out of respect for the collectors' privacy. I also firmly believe in the beachcombers' code of ethics: Hunting for sea glass is a personal and private occupation; revealing a favorite beach is a gift to be given exclusively from one individual to another.

Nothing could have prepared me for the privilege and honor I felt when I spoke with these collectors. I have been welcomed into strangers' homes and come away with much more than the information I was seeking.

INTRODUCTION

As anyone who collects anything knows, there is as much pleasure in the hunt as in the acquisition. "Seaglunkers" (a fusion of *sea glass* and *spelunker*) have the additional joy of searching for their treasure on sandy beaches and rocky coastlines. Who could conjure up a more compelling environment to inspire the collector? Then there is the fresh air, the mild exercise, and, of course, the fact that sea glass is free for the taking.

Most of the sea glass collections in this book began in the same way—individuals and families relaxing on a beach, gathering shells, stones, and sea glass as a summer pastime. For me, sea glass taps into images first planted in my mind by N.C. Wyeth's classic illustrations of Robert Louis Stevenson's *Treasure Island*, the beachside sleuthing of the Hardy Boys, and newspaper reports of newly discovered venerable shipwrecks.

Since the beginning of time, humans have created useful and decorative objects from sand, soda, and lime—the basic organic elements of glass and ceramics. These objects have ended up in oceans and waterways for numerous reasons. Cargo spills and shipwrecks contribute to the incalculable quantity of sea glass that appears on beaches and riverbanks throughout the world. Household wares tumble into the ocean in storm-battered communities, and bottles left behind after a beach bonfire eventually become sea glass. Coastal dump sites, common in days prior to environmental-protection awareness, yield some of the finest examples.

In time, these glass and ceramic shards break down and return to their original components. The unique appeal of sea glass lies in the curious mix of civilization and nature—the mystery of untold origins and the journey from past to present.

For the collector, the hunt for information about the origins of their sea glass specimens can be as complex or as limited as the beachcomber chooses. Individual shards

can be cherished simply for color, shape, and texture, but certain sea glass fragments seem to pull collectors into an open book of historical research.

While *Sea Glass Chronicles*, the predecessor to this book, focuses on the origin of individual glass and ceramic shards, *A Passion for Sea Glass* has a different purpose. This new book profiles certain passionate collectors and their collections as a whole rather than focusing on the interesting stories behind individual bits of glass or pottery.

Some of the collections revealed in these pages are profound in their simplicity, while others are massive and, sometimes, breathtaking. Some collections center on a theme or on a specific sea glass category. A few collections have launched businesses. Many are carefully sorted; others are displayed in heaps. All are extraordinary in some way, and each of the collectors has long surpassed settling for one Mason jar filled with sea glass.

Why do otherwise rational people collect vast amounts of sea glass? What compels them to abandon time and convention to satisfy their commitment to an object that most consider valueless?

These remarkable individuals—of all ages and walks of life—consider their sea glass collections central to their very existence. Most of the collectors I interviewed for this book described sea glass as a happy obsession. One called it archaeology for the soul. All of them have a passion for sea glass.

For more information about sea glass and sea glass collectors, visit the North American Sea Glass Association website at www.seaglassassociation.org

OCEAN ETUDE

If ever a musical composition translated into a work of visual art, it exists on a small island off the coast of Maine. Drawing on the memory of her father's piano playing, artist Kathie Krause utilized thousands of sea glass and ceramic shards collected over the course of forty years to create a mosaic of ocean waves on her shower walls. She worked on the mosaic over a three-and-a-half-month period.

"My life here is surrounded by water and the sounds of water—the music of water lapping the shore, moving in or out, thundering in, rolling curls through the harbor," says Krause. "In my memory, my father sits at his piano playing Chopin's 'Ocean Etude,' his fingers moving up and down the keyboard in arpeggios that express the endless undulation of the grand, powerful, and mysterious deep. This is where the impulse came from—an attempt to capture musical notes with little pieces of color—not random, but organized into rhythms."

Monhegan island life and family history permeate Krause's work. No doubt some of the sea glass and ceramic shards she uses originated from the British fishermen who first settled the island, the mid-nineteenth-century artists' colony that included Rockwell Kent, Robert Henri, and George Bellows. Krause uses only sea glass that she has found on the island. Certain shards are easily identified as dish fragments from a restaurant long gone, washing up decades after bottle and beachside garbage-day disposal and bonfires.

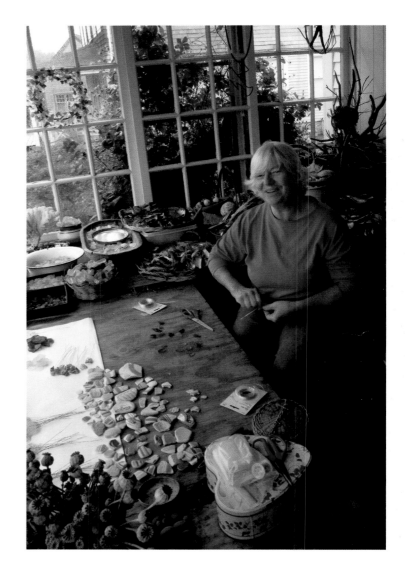

Krause's home is on the central road, where the island world passes by mostly on foot. The entrance is a significant prelude to her shower masterwork. She uses her porch as a workroom during warm months.

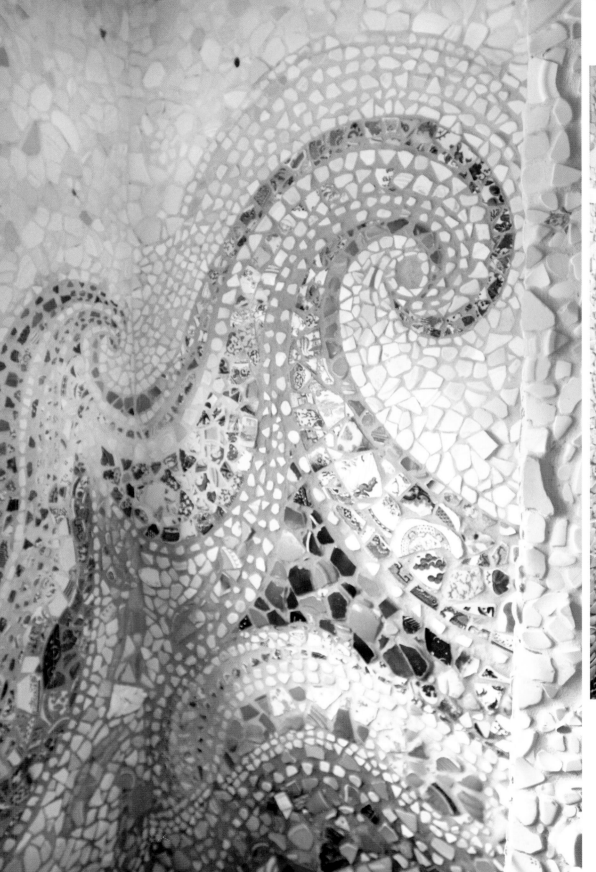

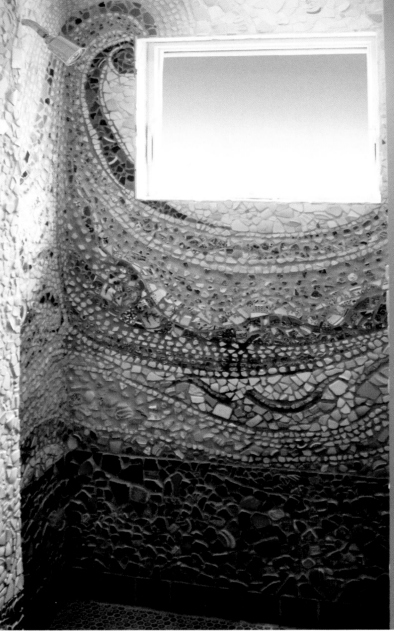

Chopin could not have imagined his music recreated in twenty-first-century interior design. But in this tiny room on a tiny island, Krause has captured "Ocean Etude" in her mosaic shower walls colored by all the moods of the ocean.

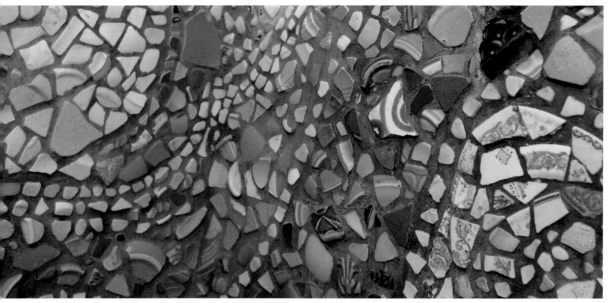

[Left and below] Krause colored areas of the grout background in watery shades in order to define and intensify the ocean drama and to set off the individuality of each shard. "I love the shape of each piece as it is found—the rounding and softening of edges that has been the work of the sea, sand, pebbles, tide, and time," she says.

Each shard was glued onto the shower walls with tile cement. Spaces between the pieces were filled in with grout, and then the sea glass was wiped clean of grout. Painting the surface with tile sealant was the final step. The shower room measures four feet, three inches wide, by two feet, seven inches deep, and eight and a half feet high.

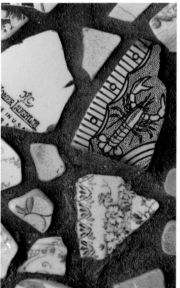
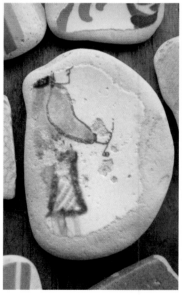
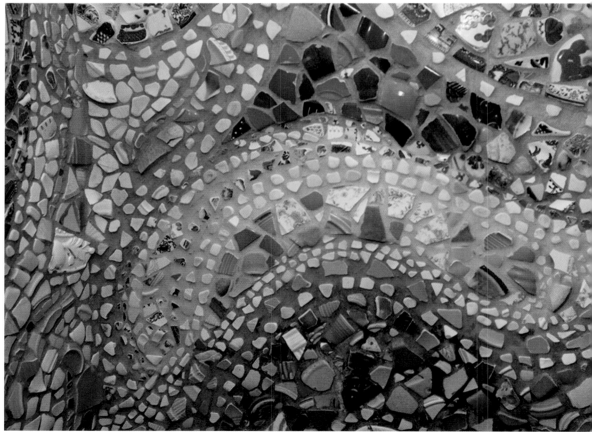

[Above left] Close inspection of the shower mosaic reveals a wide variety of nineteenth-century ceramics and Victorian transferware. The hand-painted French Quimper pottery shard in the center photo dates from

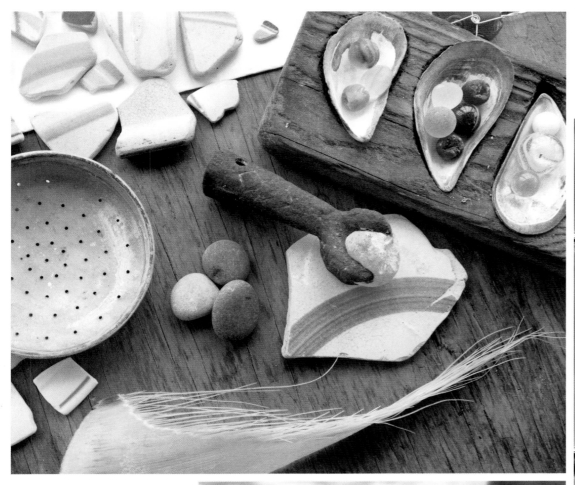

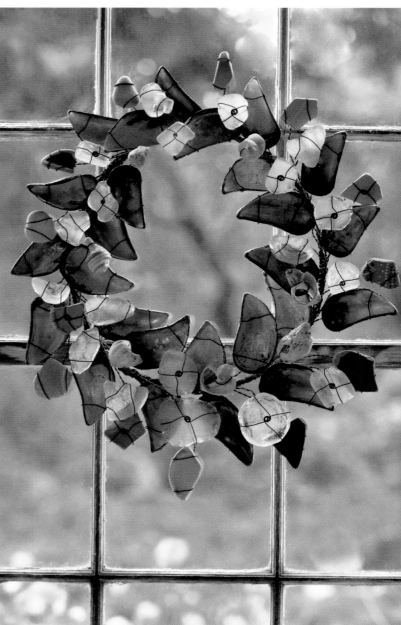

[Below] Krause is well known for her intricately constructed sea glass wreaths, which she sells in an island store, as well as in galleries and shops on the mainland.

[Above and right] Krause's brightly lit porch contains boxes, baskets, piles of sorted sea glass, and other found objects.

AIRBORNE SHARDS

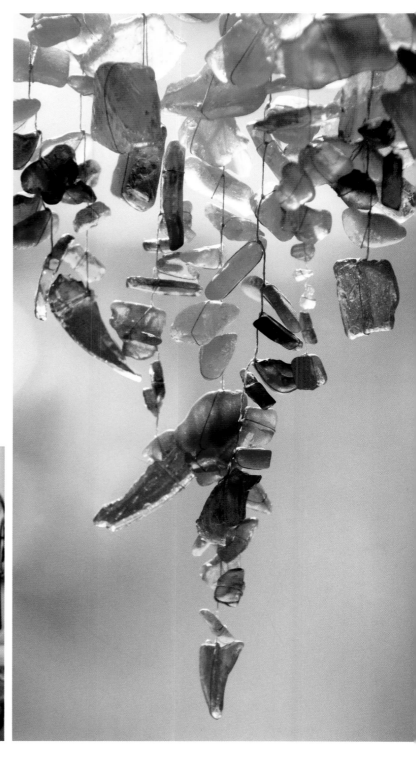

Jane Moran Porter comes from a long line of Maine islanders. She is a sixth-generation descendant of Little Cranberry's first permanent settlers, who arrived on the island in 1762. Porter captures much of that history in her sea glass mobiles, which contain beach debris that has washed up on the island for centuries.

In the summer of 1975, Porter and her twin sister opened a gift shop in an old bait shed on the island. Specializing in beachcomber art, her sister made rope bracelets and Porter created sea glass mobiles. Today, Porter owns her own shop on Little Cranberry.

"I collect sea glass for the peace of mind, for such a simple way to be happy," she says. "I could never tire of the mystery of what I will find in a minute or an hour."

Assembling her sea glass mobiles is a metaphor for her life, she says—working with each unique shard to achieve balance.

[Right] **Jane Moran Porter works on sea glass mobiles in her home office.**

[Far right] **This sea glass mobile was inspired by spruce trees along the Maine coast.**

HOW TO MAKE
A SEA GLASS MOBILE
OR WIND CHIME

MATERIALS NEEDED

Fine-gauge, transparent Spiderwire
or comparable fishing line
(available at sportfishing suppliers)

Sea glass

Driftwood piece

Super Glue or any clear, fast-drying glue

Cord for hanging completed mobile

Select desired pieces of sea glass and lay them out approximately as they will hang in the finished mobile.

Cut lengths of Spiderwire twice the desired final length of individual strands of the mobile, plus additional length for later tying the assembled strand to the mobile's driftwood frame.

Loop the wire around the first piece of sea glass and tie a square knot. Apply glue to the edge of the shard and the knot, and then tie a second, final knot atop the first.

Work on several strands at once so that each glued knot has time to dry before adding the next piece of sea glass to that strand. Space the glass pieces one to two inches apart. Continue until all strands are assembled and tied. When all the glued knots have dried, tie ends of strands to driftwood base.

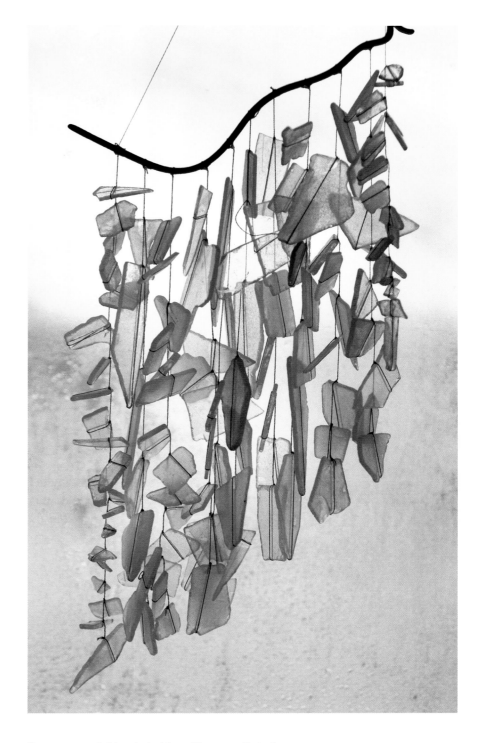

Porter named this wind chime "Summer Rain."

[Right] A mobile of necklace-like strands of tiny sea glass shards dangling from driftwood

[Far right] Porter assembles strands of shards in various designs. While some of her mobiles are light and airy, others utilize bits of sea glass in rich, dense arrays.

[Bottom right] Finely knotted Spiderwire or fishing line holds the shards together.

[Bottom left] Porter incorporates chains of handmade silver links with favorite pieces of sea glass to make jewelry she calls "sea baubles for mermaids."

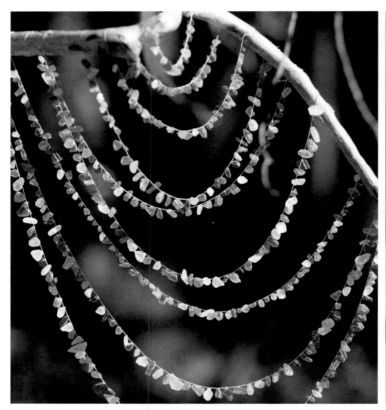

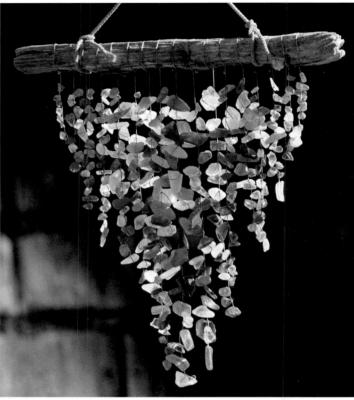

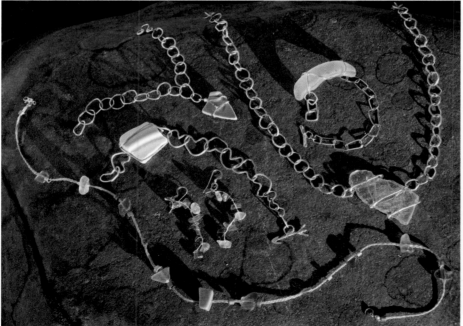

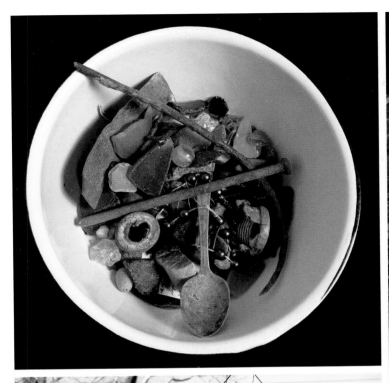

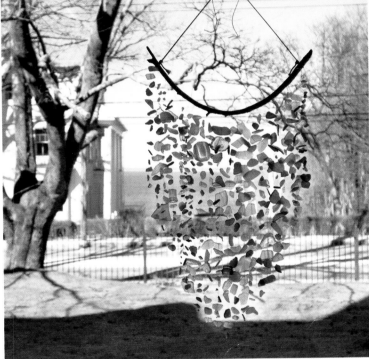

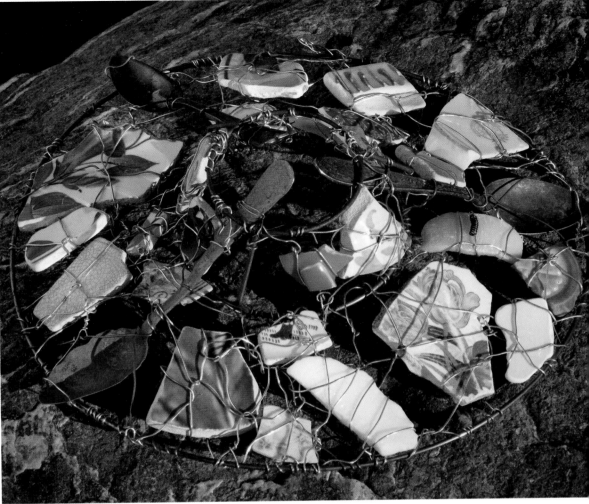

[Top left] **Collected in a bowl, this assortment of beach debris is the first step in the creation of another mobile.**

[Left] **"Confetti" is a mobile Porter made for her grandmother, Eleanor, in the early 1980s.**

[Above] **Porter's first beach debris sculpture is "Chicken Coop Attitude."**

SUMMER TALISMANS

No one in the world has elevated the perception of sea glass more than jeweler Lisa Hall. Her graceful designs grew from years of work and study in the United States and abroad. But ultimately, memories of her childhood summers in Islesford, Maine, brought her back to the Cranberry Islands, where she has since garnered international attention. Her childhood beachcombing pastime turned into a part-time local business twenty years later. Word traveled quickly on the islands, to the mainland, and finally to a much broader audience that Hall could not have imagined when she first started making her elegant, simple jewelry designs.

"My philosophy, ever since I was a kid, is that it is through a combination of luck, magic, and perseverance that one finds a great piece of sea glass," she explains. "I used to think a perfect piece would be waiting just for me because it knew how much I'd appreciate it! The pieces I collected became talismans for me when I had to return to my life and leave summer behind."

Hall's passion for the Italian Renaissance (she has a Fine Arts degree from Sarah Lawrence College and has studied jewelry making in Florence, Italy) might not be apparent, at first, in her sea glass jewelry. The ornate designs and brightly colored gemstones that predominated during the Renaissance seem far removed from the muted shades of asymmetric sea glass shards Hall uses today.

However, Hall's vision of sea glass set into sterling and gold bezels translates into a revival with a contemporary spin—discarded objects reborn as works of art.

Lisa Hall stands in front of her first studio, a renovated lobsterman's shed on Great Cranberry Island. (Courtesy of Lisa Hall)

[Right] Thousands of shards are sorted according to size and color. Hall does not tumble, polish, or alter the sea glass. She points out that the natural textures and shapes are magical, and that artificial sea glass is too uniform.

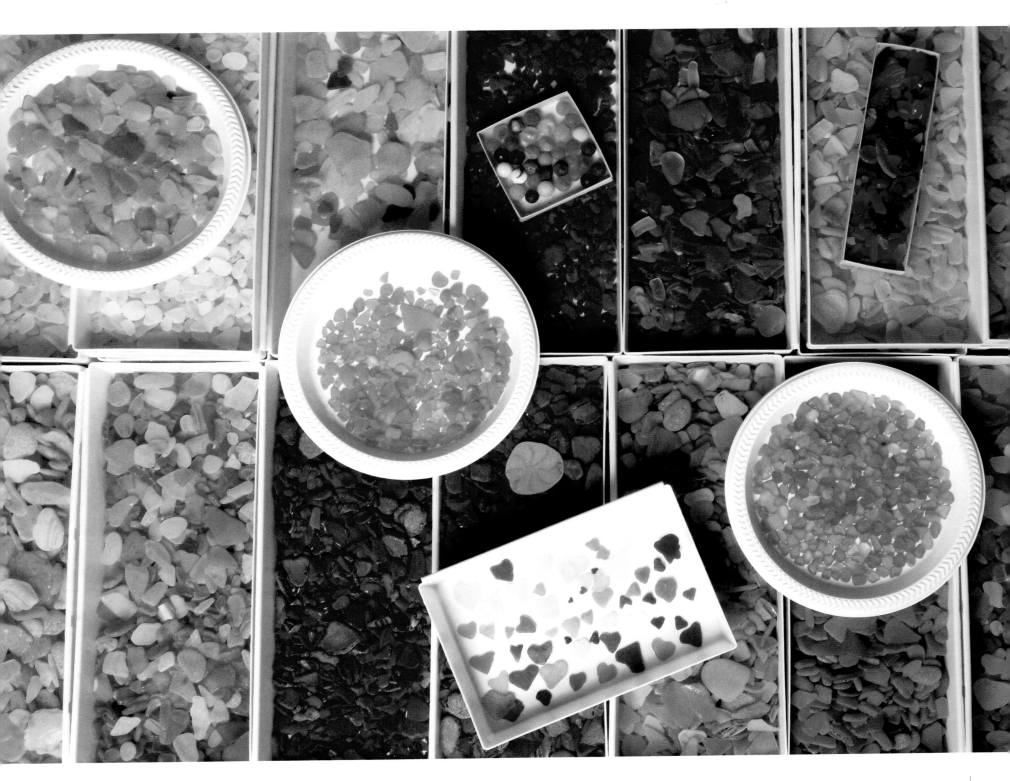

HOW TO MAKE
SEA GLASS JEWELRY

MATERIALS AND EQUIPMENT NEEDED

Strips of sterling silver or gold

Acetylene or oxygen torch for soldering

Flex shaft for grinding

Electric buffer for final satin finish on the metal

Cut a thin strip of metal to the approximate circumference of a piece of sea glass to form the bezel. Cut another piece of metal to closely approximate shape of the sea glass to form the back.

Wrap the strip of metal around the edge of the piece of sea glass, then cut to exact length. Position the bezel strip on the metal backing piece.

Solder together the ends of the bezel strip, and then solder the strip to the back all around the edge.

Inset the glass shard. Cut and crimp the bezel strip over the edge of the glass to hold it in.

Smooth the soldered edges with the flex shaft.

Solder an earring back or ring to the metal back.

Buff the metal for a satin finish.

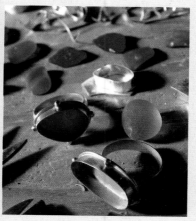

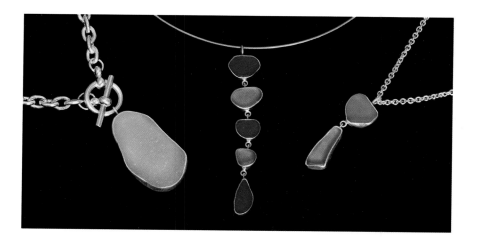

Left to right: a sterling toggle necklace with a chunky piece of Georgia green sea glass; set in 14-karat gold, cobalt and cornflower blue shards alternate in a five-drop pendant; a lime and cornflower blue double pendant.

This sterling necklace encompasses the cool blue sea glass spectrum. These shards probably originated as early Milk of Magnesia, Vicks VapoRub, Bromo-Seltzer, and poison bottles.

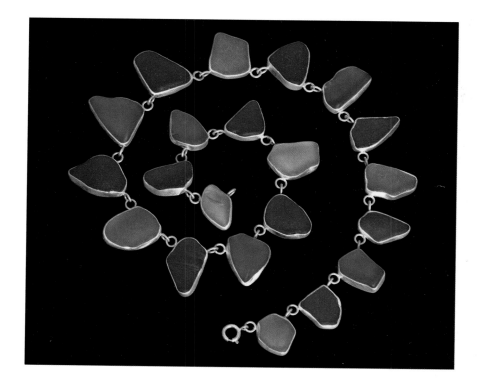

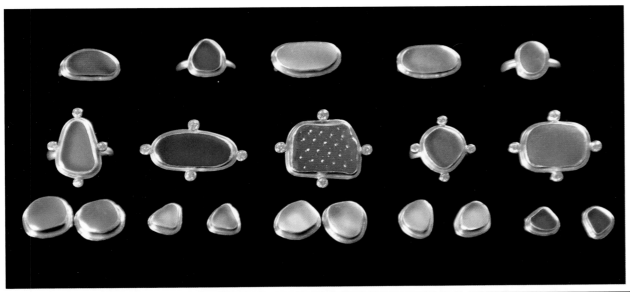

[Left] Examples of 14-karat gold jewelry:
Top row: sea glass rings; middle row: sea glass rings with diamonds; bottom row: stud earrings.

[Bottom left] The white, frosted shards began their journey as transparent glass. After decades being tumbled by surf and sand, these abraded white shards might be mistaken for larger versions of the pearls that alternate with them
in this sterling silver choker.

[Bottom right] Two centuries of china patterns, including mulberry, flow blue, chintz, and Fiestaware, are represented in this necklace.

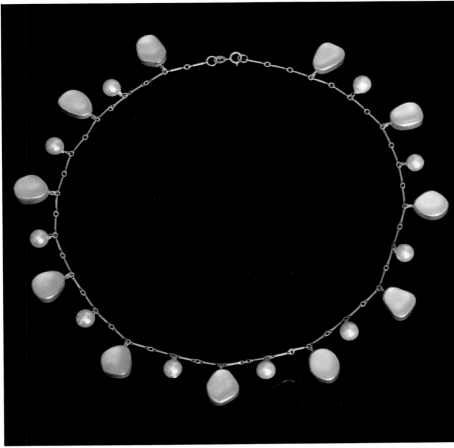

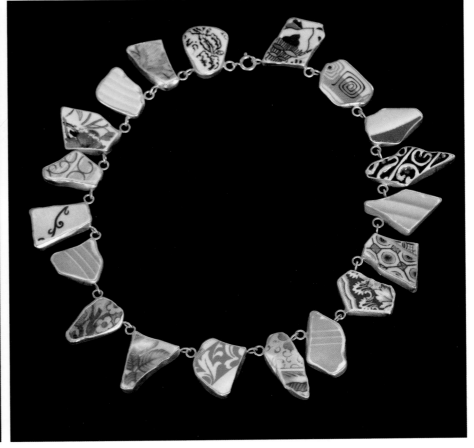

[Right] A soft green shard is the perfect jewel for Hall's sterling silver baby spoon.

[Far right] A sterling silver bracelet features three shards of nineteenth-century blue and white transferware pottery and four cobalt glass pieces. In the lower left, a fragment of early pressed glass forms the base for a brooch inset with three shades of blue shards.

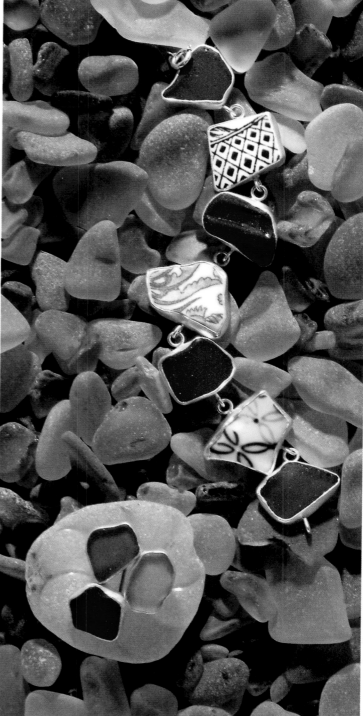

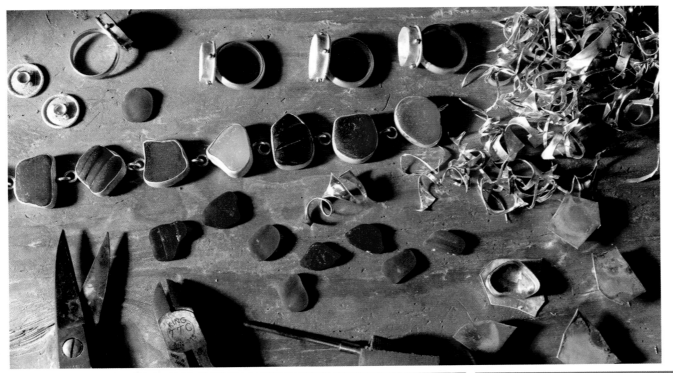

[Top] Early, middle, and end stages of Hall's creations rest on her work table.

[Bottom left] These elegant pieces of jewelry most likely came from humble origins: the cobalt cufflinks from medicine bottles, and the shirt studs from baking soda bottles or fruit jars.

[Bottom right] "Sea glass is also the closest thing to archeology I know. I grew up fascinated by ancient Egypt and other cultures," says Hall. "I always wished I could discover treasures." Hall created this full-size tiara with sterling silver, voile, pearls, and
sea glass.

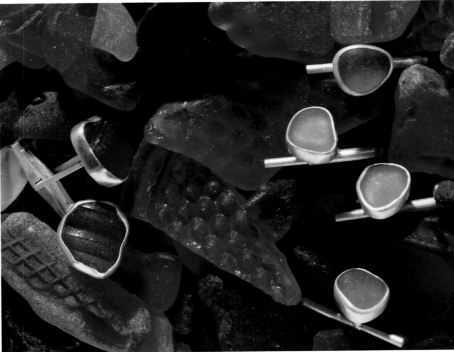

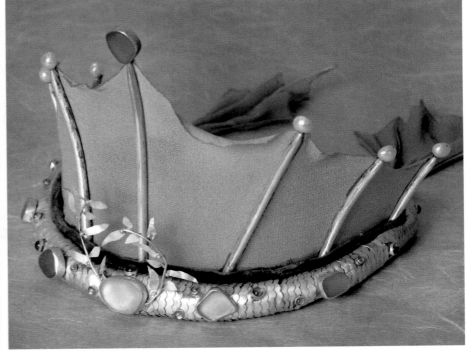

MERMAID'S TEARS

While no one knows who first described small oval-shaped pieces of sea glass as "mermaid's tears," surely Maine artist Mimi Gregoire Carpenter forever secured the term in the beachcomber's vernacular. In her book *Of Lucky Pebbles and Mermaid's Tears* (Beachcomber Studio Press, 1994), she evokes a particular melancholy—one tinged with hope that myths might be true.

An artist, author, and teacher, Carpenter is widely known for her opaque watercolor illustrations of objects and creatures that wash in with the tide. Sea glass figures prominently in her rendering of shells, bait bags, dried seaweed, mussel shells, whelks, and stones. Carpenter has created an original genre: tide pool art.

"My earliest memories of gathering were of visits to Pemaquid with my parents," says Carpenter. "It wasn't long before gathering became an obsession. My pockets are always filled with sand and shells and bits of sea glass. My daughter and husband had no choice but to join in the hunt. Watching my daughter bent over, intensely searching for a bit of magic became the motivation for my books.

"My husband and I stayed in a bed and breakfast in Eastport recently, and each room had a dish filled with sea glass. The hostess swore us to secrecy and shared her secret spot with us. We filled our containers with glass more precious and fascinating than any diamond or emerald in a store window.

"We wondered about the previous owners of this treasure. We were fascinated by its evolution, grateful that we were the ones who found it. Were these shards left by mermaids or sea fairies? I love the world of make-believe, and I have tried to live my life somewhere in between. Play and work are one and the same for me as an artist."

[Above] **A road sign points the way to the studio.**

[Right] **Baskets full of subject matter line the shelves in the studio. Displayed among the beach finds is a photograph of Carpenter's daughter, Tessa, who is also an artist and passionate beachcomber. Tessa was the inspiration for her mother's first two books, *What the Sea Left Behind* and *Mermaid in a Tidal Pool*.**

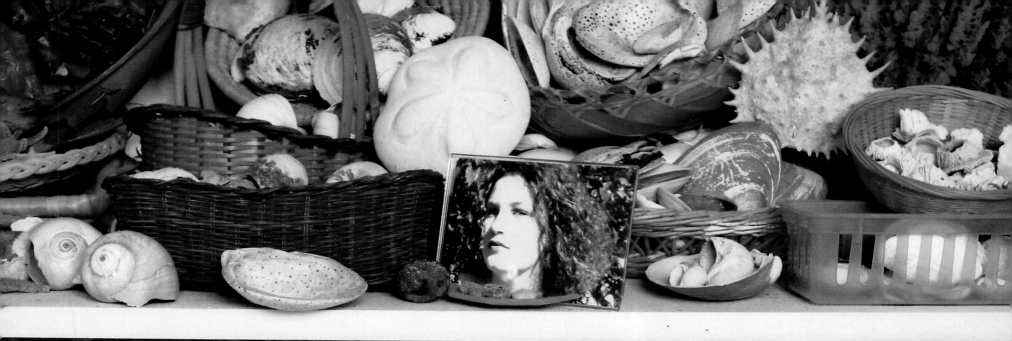

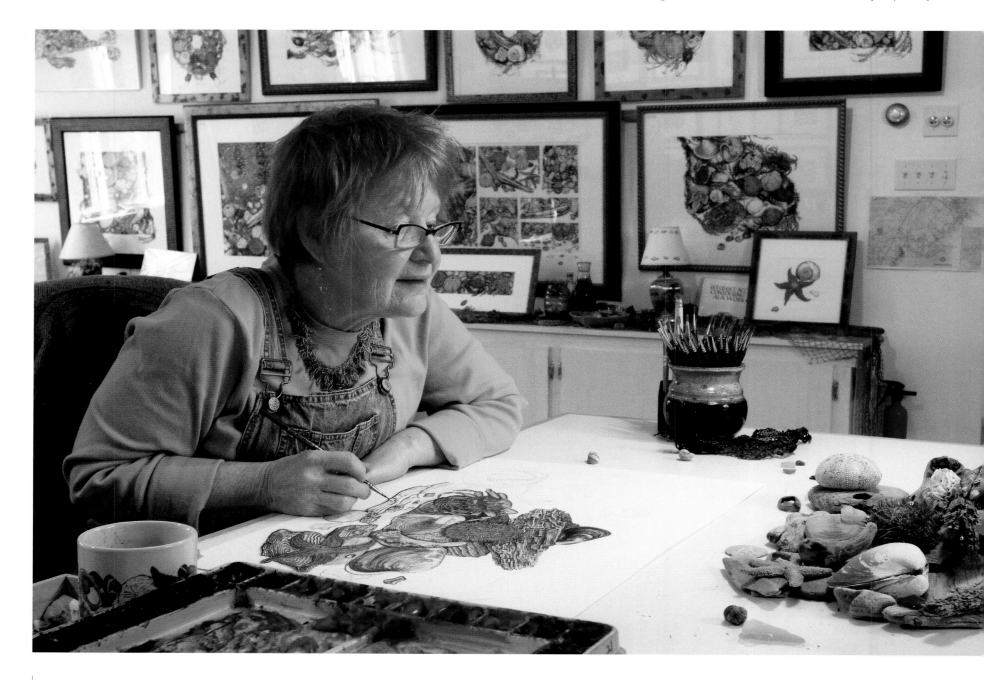

[Below] Carpenter works from a still life of driftwood, shells, and glass gathered at Hills Beach near her Beachcomber Studio.

[Top right] "After the Storm" is a collection of treasures gathered at Goose Rocks Beach in nearby Cape Porpoise.

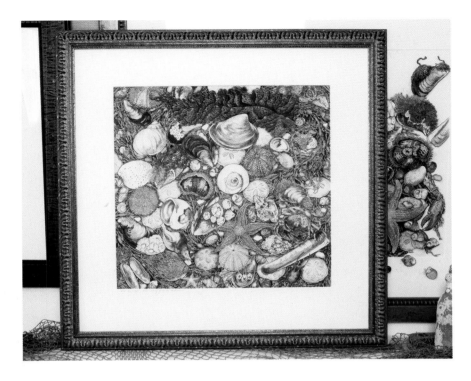

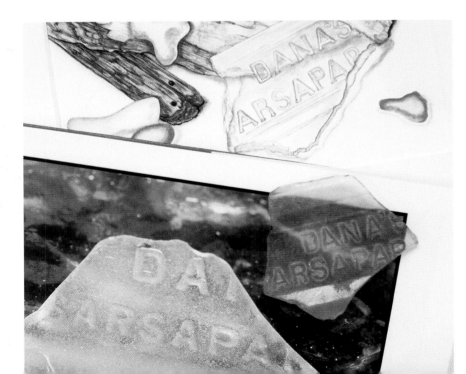

[Below] By definition, each piece of sea glass is unique. However, fragments from two nineteenth-century sarsaparilla bottles—one from Carpenter's collection and another from the author's collection that was photographed in *Sea Glass Chronicles*—reveal an eerie similarity.

HOOKED ON SEA GLASS

Hanging in Mimi Carpenter's studio is a rug designed and created by rug hooker Becky Ford, who views her art as textural painting with wool. Depicting a mermaid surrounded by shards of sea glass, the rug was inspired by Carpenter's book, *Of Lucky Pebbles and Mermaid's Tears*.

Ford herself became enchanted with sea glass years ago while she and a friend were beachcombing. Her friend picked up a few tiny shards of sand-buffeted glass and said, "These are mermaid's tears."

"Feelings of surprise and joy from that day still resonate when I find small pieces of sea glass," says Ford.

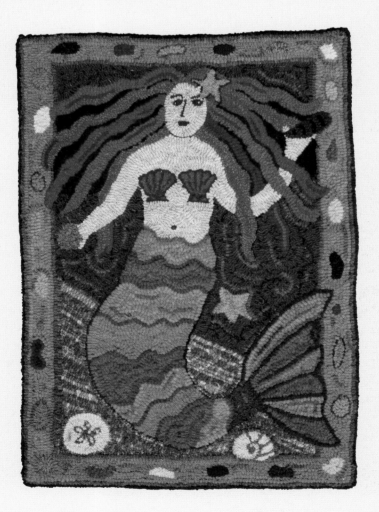

ANCESTRAL SUMMER LEGACY

Since 1927, the Osgood family has spent summers in a family enclave in Ducktrap, Maine. For four brothers and their families, as with previous generations, beachcombing is still a serious summer occupation in the bay off their backyard.

Sea glass appears in all four cottages, but only in Deeda and Tom Osgood's house do vast amounts of sea glass result in a series of perfectly random still lifes.

"We have so much sea glass that I am running out of room for it—vases full, windowsills covered. I separate colors: pastels in one vase, green over there, old milk jugs filled with white glass and one with brown glass, which we refer to as chocolate milk, and glass from Italy is separated on its own," says Deeda Osgood.

Osgood always picked up "beach stuff," but began collecting sea glass when she first went to Maine in 1982 at age eighteen. As she spent more and more time in Maine, she says, her "passion for sea glass turned into somewhat of an obsession." Her children, too, have been collecting "ever since they could walk."

Sea glass even makes it way to the Osgood's winter home in Santa Fe, and she created jewelry with "certain special pieces."

Searching for sea glass "is meditative and has a calming effect on the soul," Osgood believes. "There is nothing like spotting a beautiful treasure that has washed up on the sand, waiting to be found. Each day brings a new treasure with a new mystery behind it, and I enjoy the challenge and suspense of what I might find."

Osgood admits that some friends and family members wonder why she collects what they perceive as trash. Her answer: "In my mind it is a valuable sea gem created by nature over a long period of time, and that gives it a unique and immeasurable value."

[Above] Cobalt and cornflower blue shards mix with the equally coveted lavender shades on a bed of sand dollars.

[Right] Fourth-generation Osgoods, Hull cousins, and friends show the morning's sea glass harvest.

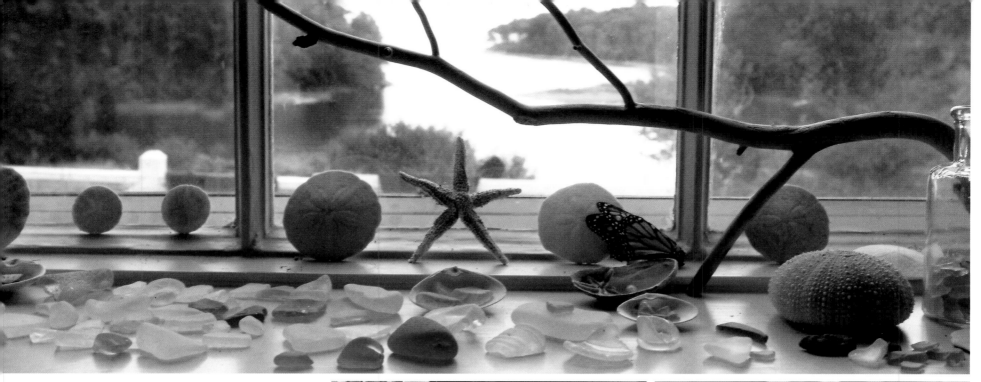

Surfaces throughout the family cottages reveal sea glass troves four generations in the making.

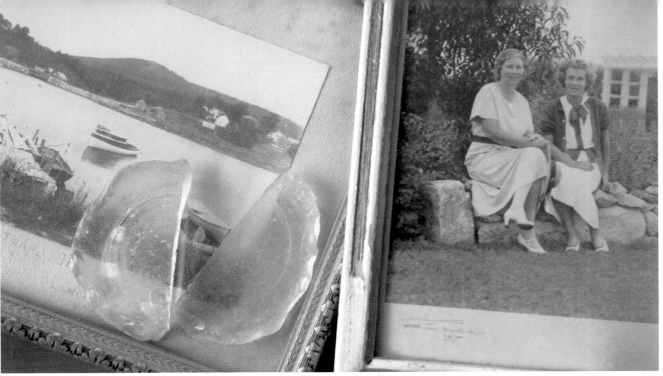

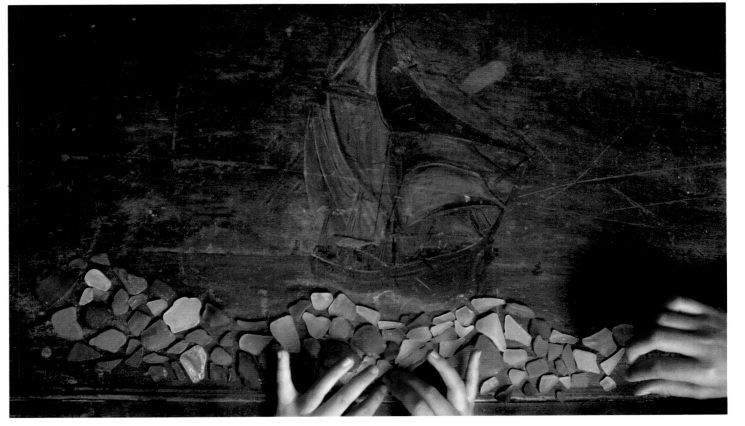

[Top] The framed photo on the far left shows the family beach during the 1940s. Sitting on the photo are two perfectly matching fragments of an early bottle bottom found a decade apart by Ravenna (right, modeling pendants) and her grandmother, Elizabeth Paine Osgood (figure on the right in the black-and-white photo).

[Left] Ravenna Randall Osgood and friend Emma Cloyd create a sea glass ocean on top of an antique sea chest, an Osgood family heirloom.

WINDOWS & DOORS FOR GNOMES

When Dennis Sheehy goes to work in the morning, he doesn't have far to travel. His office is located in his spacious living room where tools are set out on an L-shaped workbench. Throughout his house in Portland, Maine, boxes, bags, even windowsills contain the elements of Sheehy's trade—driftwood, fragments of lobster traps, miscellaneous found objects, and especially sea glass. His full-time occupation also requires that he spend significant time combing nearby beaches. Sheehy is a well-respected and much-in-demand architect and builder of Gnome Homes.

Sheehy hunts for relatively flat, square, well-weathered sea glass, which he uses prominently as windows and in doors. Set into earth-colored driftwood, the sea glass appears almost fluorescent.

"Sea glass adds a tone of mythology, playfulness, and color to my work. It is also found material, and that is fun and challenging to use in artistic ways," he says.

These miniature, elegant, craggy edifices are a product of Sheehy's imagination and a culmination of life experience. According to Sheehy, his B.A. in English Literature from St. Bonaventure University contributed as much to his Gnome Homes as his thirty years' employment in the corporate world.

Literary influences abound in Sheehy's work. And while leaving an established career might seem risky to most, Sheehy believes that creating these miniature dwellings has brought order to his life. "It is a spiritual rebuilding," he says. "I love making something out of found objects, which are beautiful in themselves. I needed the human connection, and that flows freely in my life now."

Construction time for a Gnome Home averages ten hours, although Sheehy once spent a hundred and fifty hours building a Gnome Cathedral with ornate sea glass

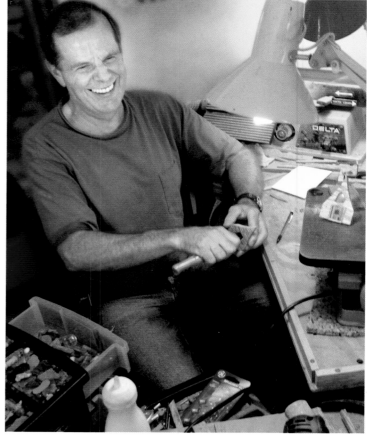

Dennis Sheehy placed his workbenches in the heart of his home. Using a scroll saw, belt and disk sanders, four Dremel tools, and numerous small hand tools, he crafts his Gnome Homes entirely from objects found on the beach. He uses Titebond III waterproof glue and stainless steel screws because many people like to place his work in their gardens.

windows giving a stained glass effect. Each building is entirely unique, and some offer secret passageways that lead to secret rooms.

"Sea glass is an artifact, but one that has been transformed by the action of the sea and sand, often yielding shapes and colors that couldn't be obtained by human skill alone," he says. According to Sheehy, finding a perfectly abraded blue shard is much harder today than in 1992, when he began hunting for sea glass. Red and pink are even scarcer.

On average, Gnome Homes measure one and a half feet square by one foot tall, and the smallest Sheehy ever built was three inches tall. "Mahaloha Menehune," the largest, weighed fifty pounds, measured about four feet by three feet, and was shipped to clients in Kilauea, Hawaii.

"I tell people I'd rather find a uniquely beautiful piece of sea glass on the beach than a thousand-dollar bill," says Sheehy. "Obviously, a thousand dollars would buy wonderful pieces of sea glass, but part of the fun is finding it as an offering of nature itself."

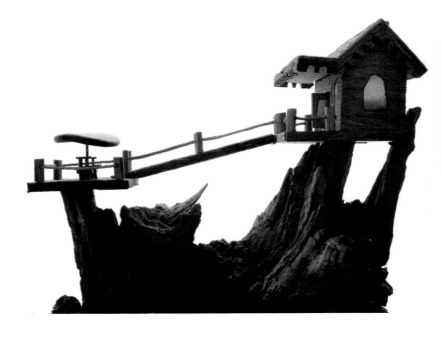

[Above] This elevated Gnome Home features a diminutive picnic table and umbrella, hand-tooled railing and ramp, gingerbread moldings, and sea glass windows.

[Left] Frank Lloyd Wright would have appreciated this structure, reminiscent of the acclaimed architect's own designs. Sheehy named this building "Dance Land," and one can imagine gnomes jiving the night away behind those swinging doors.

[Right] Several examples of Gnome Homes occupy Sheehy's bay window. His cat, Garfield, inspired the one called "The Magical Cat," where rare cobalt and ruby glass shards glow eerily when the interior light is switched on.

[Below] Situated on a large piece of white-oak root that drifted up in Falmouth, Maine, the "Mahaloha Menehune" complex has a main house, a lighthouse, and a tree house, all illuminated for outdoor display near a pond. Rare red sea glass plays a significant part in the color scheme. Sheehy created the name by combining two Hawaiian words: *mahalo*, meaning "thanks" or "gratitude," and *aloha*, meaning "hello with love" or "affection." The second word, *menehune*, is the Hawaiian version of "gnomes," resulting in "Hello with love, Gnomes." (Courtesy of Jay York)

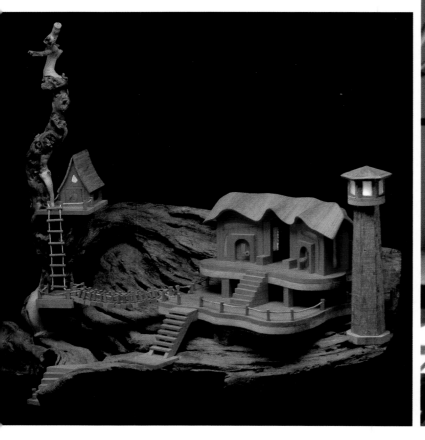

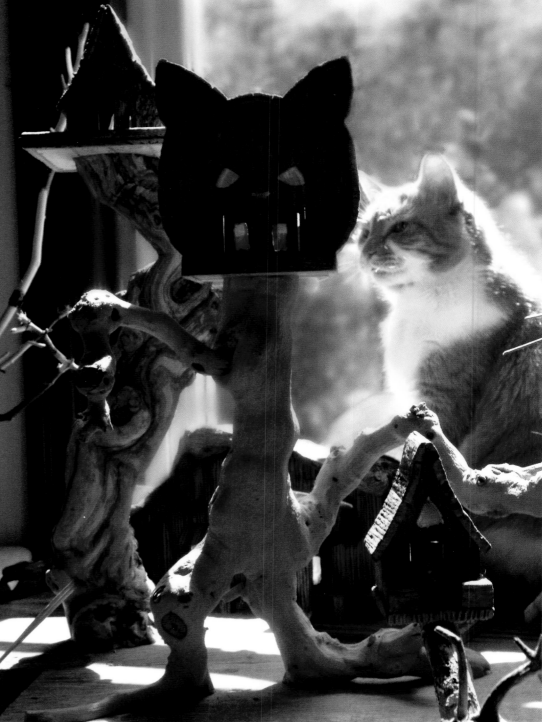

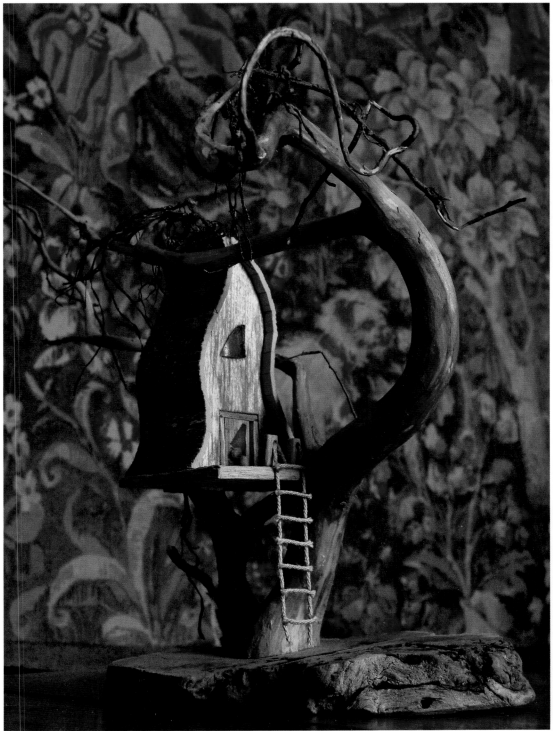

[Above] "Inside the Mystery"

[Left] "Mystical Roque Woods" has a particularly strong fairy-tale aura.

[Below] Flanked by glass and ceramic shards that will eventually become part of more Gnome Homes, a black-and-white photo shows a three-year-old Dennis Sheehy conversing with a life-sized gnome.

ANTHROPOMORPHOUS FRAGMENTS

When Barbara Burnham and her daughter Melinda Conrad of Gloucester, Massachusetts, started sea glass collecting, they became hooked early on. Conrad describes their favorite activity as a scavenger hunt that grew from a hobby to a passion, and now to an obsession.

Sea glass is displayed throughout both their homes—in bowls and dishes, on shelves and tables, and in shadow boxes. In addition to the large volume of sea glass, these two collections probably contain the largest number of porcelain and ceramic doll shards ever found. These two ladies will not divulge specific beach locations beyond acknowledging that they found all the doll fragments on New England beaches.

Both find beachcombing therapeutic, relaxing, and, according to Conrad, mystical.

"The pieces of sea glass that are truly gems are in my private collection, which I am saving to share with my grandchildren," she says. "I love taking pictures of my glass and sharing it with others. I love to talk about it."

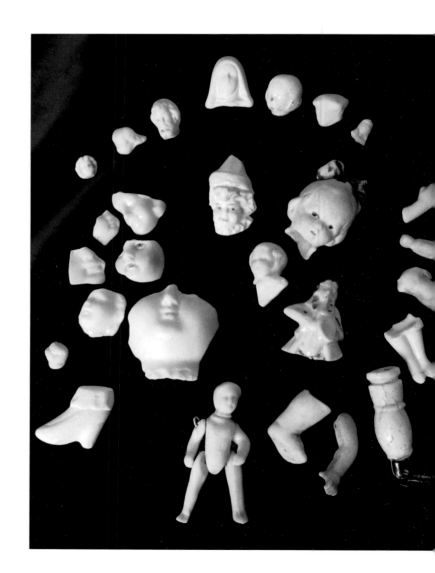

The variety of doll and figurine fragments in Burnham's and Conrad's collections is remarkable. This group represents French, German, English, and American manufacturers. Some of the face pieces still retain hand-painted details, due to minimal wave action in the harbor where they were found.

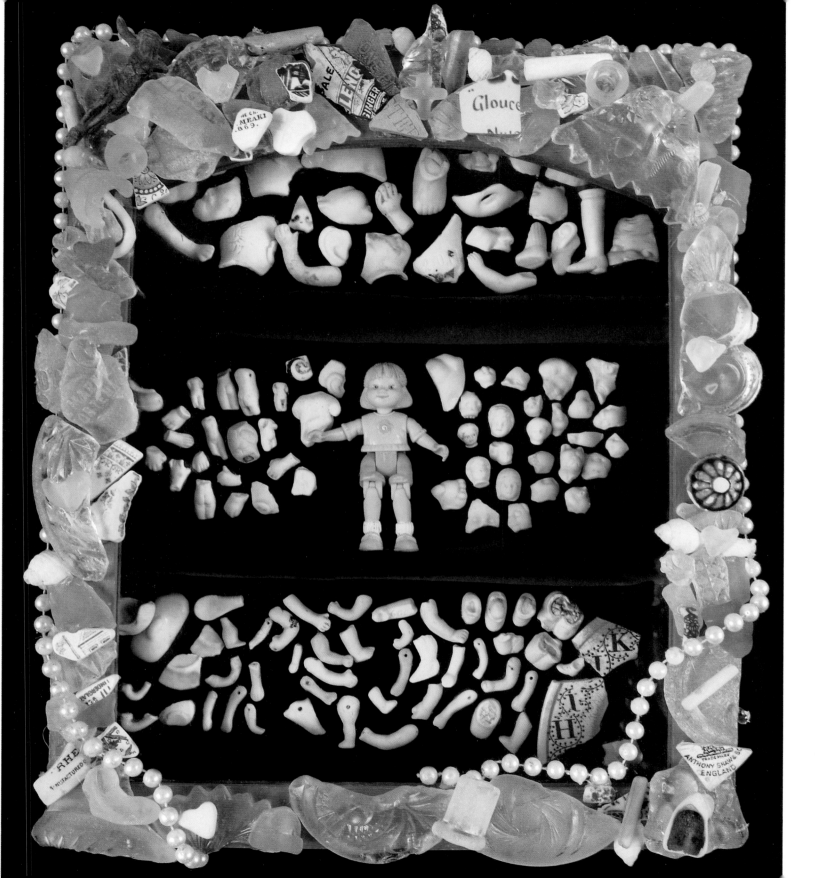

Bordered by more widely collected pieces of sea glass and ceramic shards, this shadowbox contains all manner of tiny ceramic body parts (plus one contemporary plastic doll still intact).

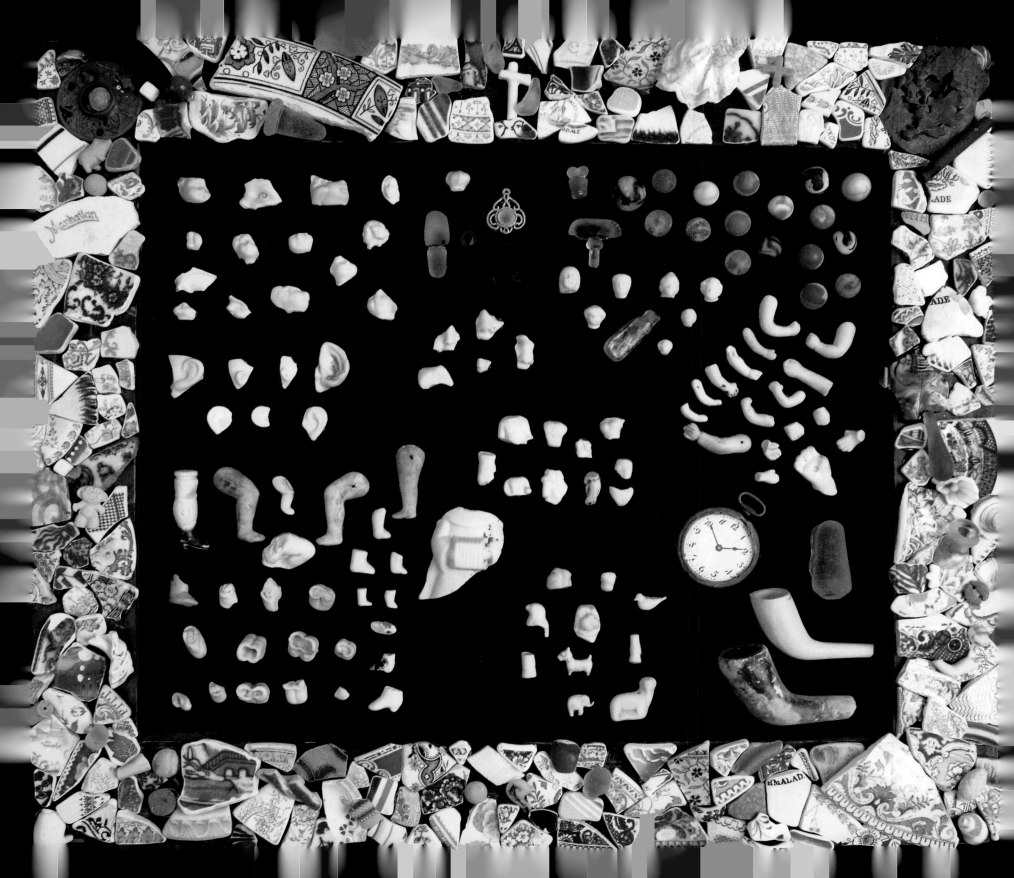

[Opposite and below]
This shadow box holds the gamut of the finest beach treasure. Imagine finding a headless, accordion-playing nun rolling in the surf or a fat china baby's leg (photo inset).

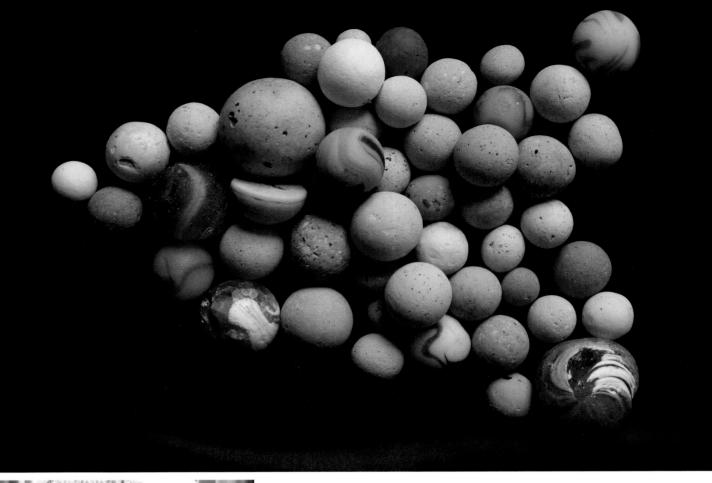

[Above] Clay and glass marbles are another rare and much sought after beach treasure.

[Left] Melinda Conrad and her mother, Barbara Burnham, have filled most surfaces in their two homes with sea glass and ceramic shards.

SEA GLASS
FENG SHUI

While most of the other sea glass collections in this book are extensive, this one speaks volumes through its simplicity. Dr. Susan Frey of Gloucester, Massachusetts, combined careers in healthcare and architectural design with her love of beachcombing and created a harmonious and deeply personal environment at home.

The ancient Chinese philosophy of *feng shui,* the practice of placement and arrangement of space to achieve concordance with the environment, strongly influences Frey's life and work. She integrates sea glass in her home according to these principles and believes her life is enriched as a result.

According to Frey, sea glass is a metaphor, "a sojourn into other worlds that can change your life. But you have to be looking for it in order to see it."

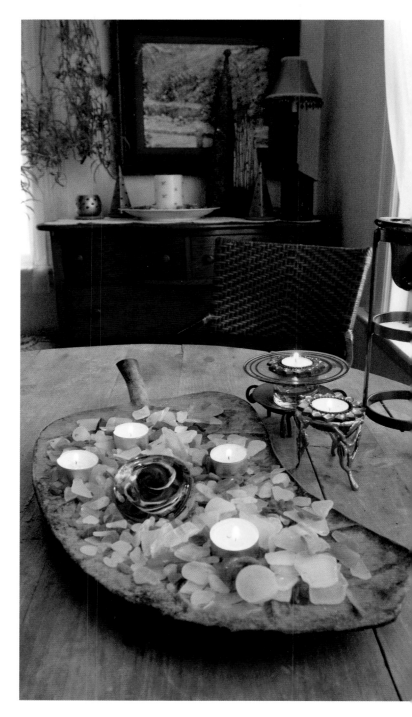

Tea lights illuminate a metal leaf dish filled with sea glass.

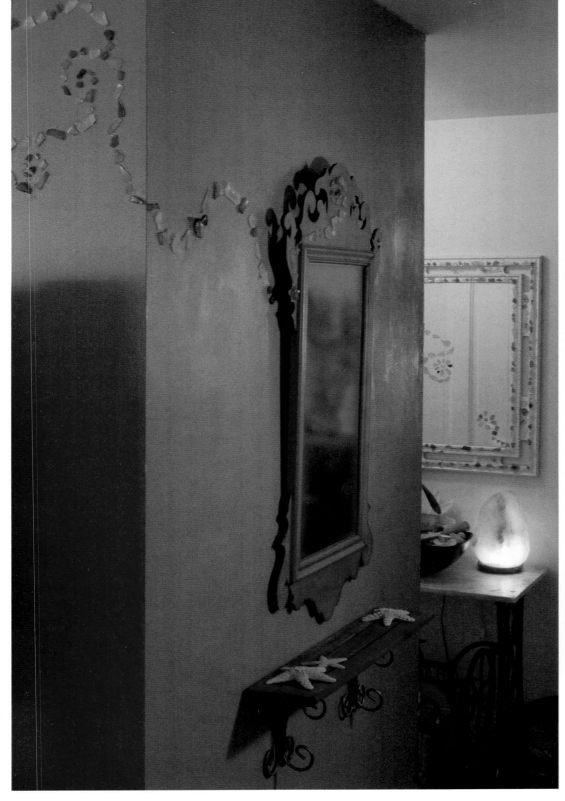

[Left] On one central sea-green wall in Frey's home, a Victorian mirror appears to release a tendril of sea glass shards that continues around the corner to the converging wall of a strikingly different color. In the background, another mirror bordered with shards holds more sea glass on its surface, which also reflects a sea glass design on the facing

[Above] A simple dish contains found objects that represent the five elements: earth, water (sea glass), fire, metal, and air.

ISLAND MEMORIES

Auctioneer, painter, and wooden-boat builder Larry Trueman always collected beach treasures on Peaks Island, Maine, but it wasn't until he moved off-island in 1985 that his shards turned into an avocation.

Each time he returned to the island he picked up sea glass and ceramic fragments to bring back to the mainland. "I wanted so much to take a part of it home each time I was there," he says. "It was a connection thing, I guess. It sounds corny, but I am sure I am not alone with this feeling."

Trueman paints miniature nautical scenes on ceramic shards, often incorporating the china pattern designs. "The paintings represent the history of the shard and what the island and bay might have looked like during the eighteenth and nineteenth centuries when the ceramics were being imported to America. The tide and time have brought these shards to me on the beaches to show me how it was.

"They are truly a romantic mystery, for nothing can speak other than the china itself."

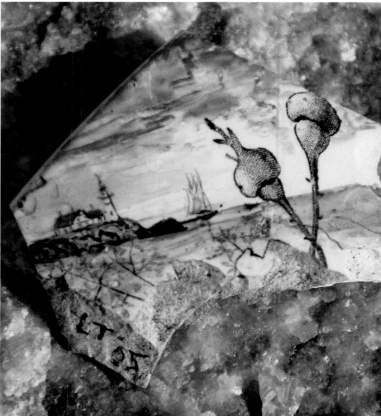

[Above] Trueman painted Portland Head Light into the transferware design on this 1870s ceramic fragment.

[Right] The small shard in front depicts the lighthouse on Ram Island, which today is populated only by sea gulls. The other shard paintings capture Maine's Portland Head Light with a passing fishing schooner and a large coal schooner passing a high bluff. The shard painting on the right shows a schooner skimming ahead of a summer squall.

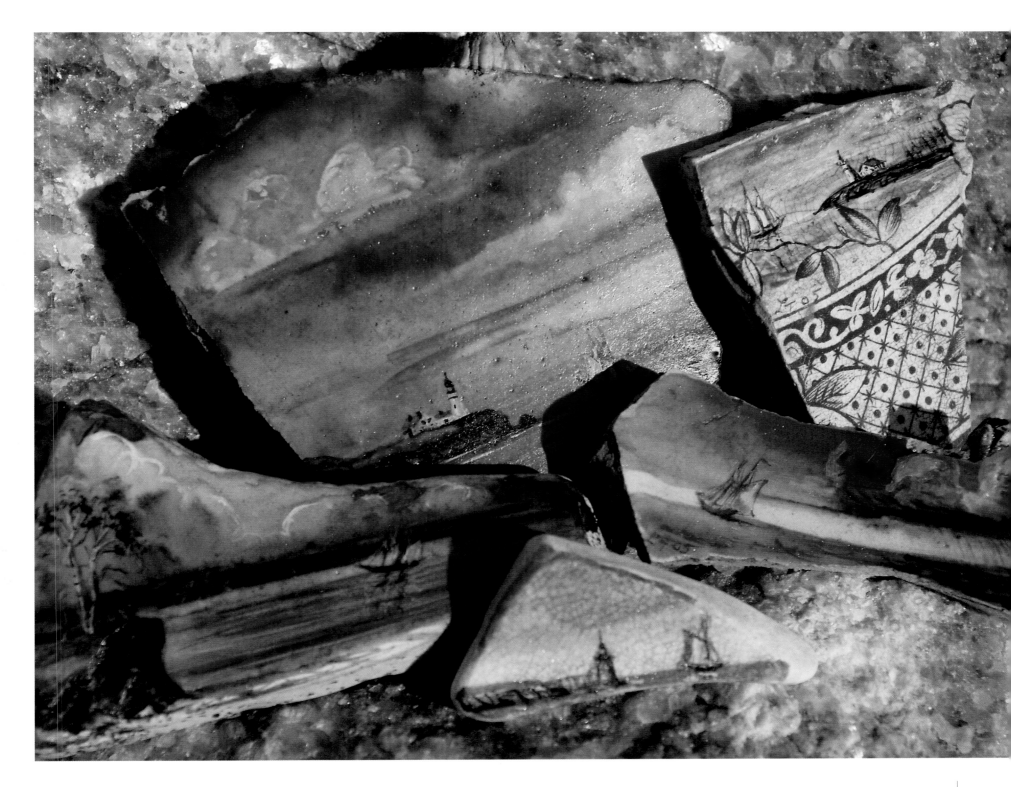

INTREPID SEAGLUNKOLOGIST

Asked when she started collecting sea glass, South Portland, Maine, resident Linda Mehlhorn replies, "When I started walking." Forty years later she built a sea glass waterfall in her backyard so that the calming sound of water rolling over sea glass is ever-present.

"'Seaglunking' is my mental therapy. It allows me to clear my mind, and it stimulates my imagination about past times and people," Mehlhorn says. She invented this word that has become pervasive in the beachcombing community. A combination of *sea glass* and *spelunking* (cave exploration), *seaglunking* means exploring a beach or riverbank for sea glass.

In addition to the waterfall, Mehlhorn's collection consists of shards on windowsills and filled jars throughout her house; a mobile in her office; a living room wreath; a sea glass–filled lamp in her bedroom; a hallway mirror bordered in selected shards; sea glass wineglass charms; a drawer full of special pieces; and a massive outdoor tabletop and second sea glass lamp in her backyard. In the basement, "waiting to be transformed into something useful and beautiful," are another fifteen gallons of sea glass.

"The pieces I find are very personal. If I share them with you or invite you to go seaglunking with me, you will know *you* are important to me."

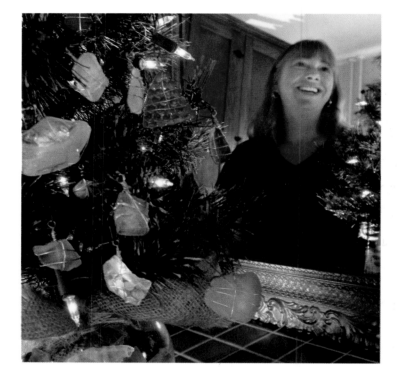

[Above] **Mehlhorn**—in the mirror reflection—decorated her Christmas tree with sea glass shards. A glass bowl with more shards anchors the miniature tree.

[Opposite]] **Mehlhorn** created an outdoor coffee table using an antique cast-iron stove bottom for the base and a wooden framed top. Ceramic shards and a tile border were grouted into the top, which features pipestems radiating around a teacup handle in the center, and shards representing two centuries of European and American pottery.

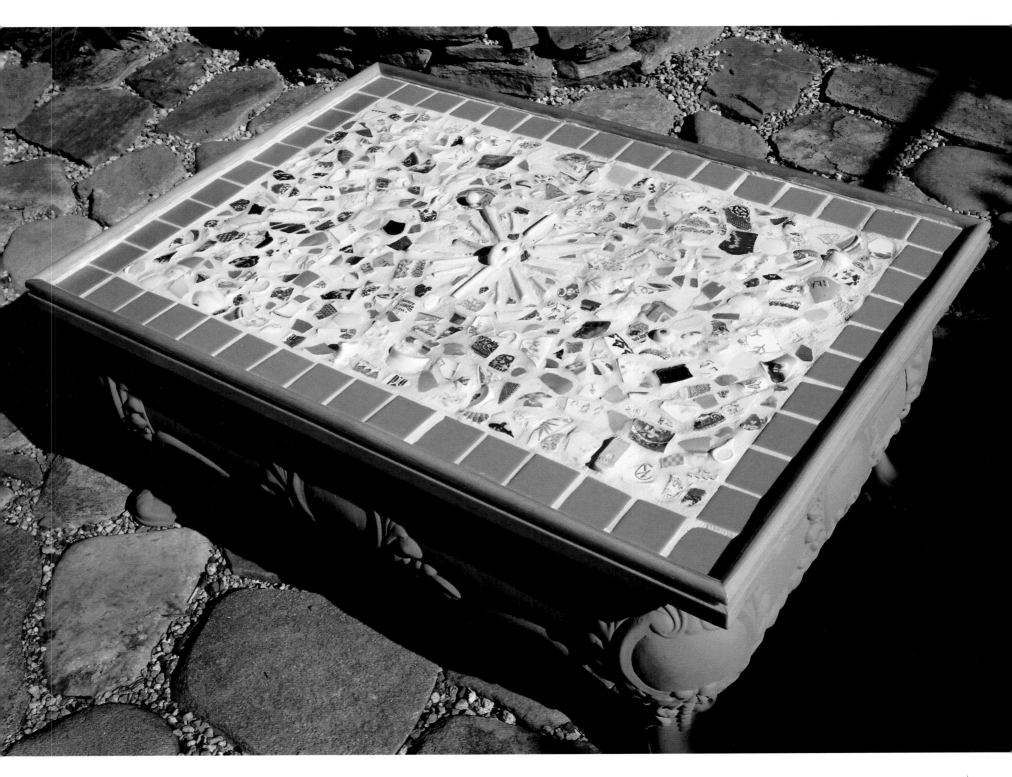

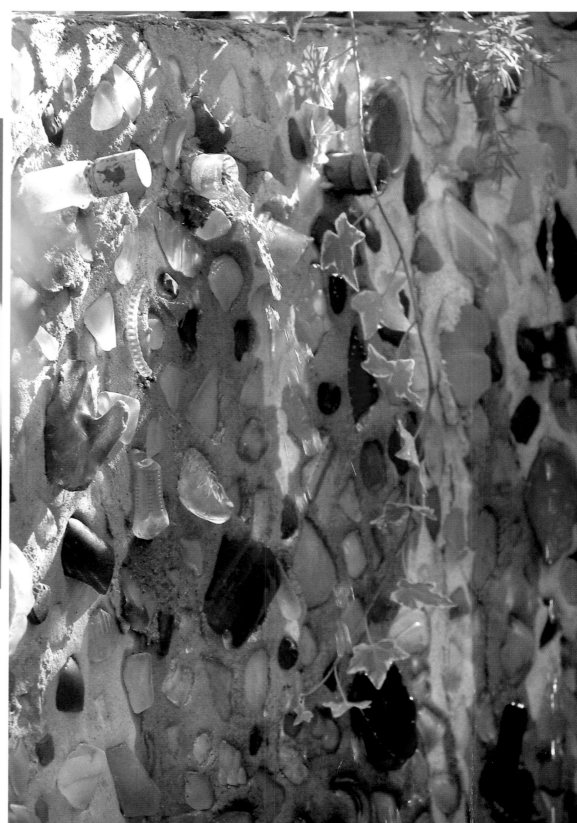

[Right] Water trickles from ten antique bottlenecks spaced along a fountain wall of sea glass measuring eight feet long by three and a half feet high, creating a delicate waterfall effect.

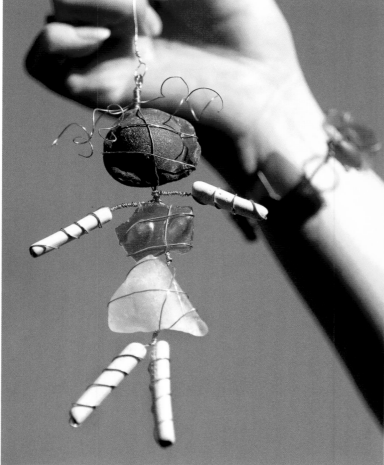

[Above] Mehlhorn created this sea glass mobile figure, named "Ruby Booby," using a bottle pontil for the head, clay pipestems for the arms and legs, a fragment from a hobnail cranberry glass candy dish for the decidedly feminine chest, and a fragment of Coca-Cola bottle for the skirt. In the background, Mehlhorn is wearing a sea glass watchband.

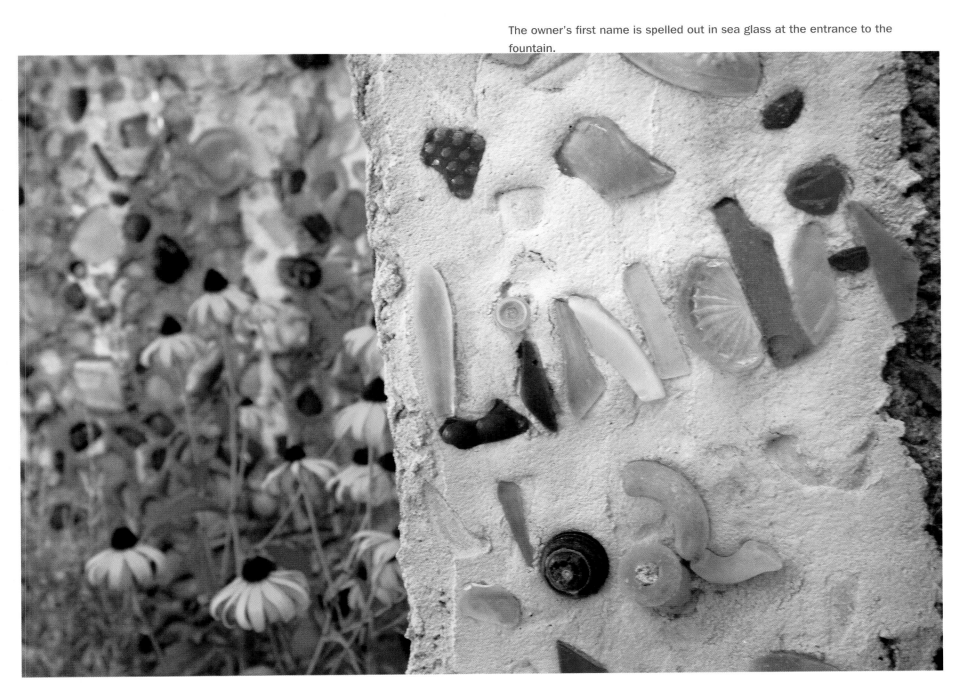

The owner's first name is spelled out in sea glass at the entrance to the fountain.

SIGN OF THE TIMES

A familiar beach, a stranger, and large piles of sea glass—these are the elements that first turned artist Anna Coniaris Comolli of Gloucester, Massachusetts, into a collector ten years ago. Walking along the city's landmark boulevard, Comolli explains, she noticed a man picking up objects from one particular spot in the sand. When she aproached, the stranger said, "I have all I want. Help yourself," referring to an array of sea glass and ceramic shards that measured about two and a half feet in diameter, and a second cache a few feet away.

Before she could ask why so many shards were lumped together, the man was gone. Comolli picked up a few pieces and went home. However, she could not stop thinking about the large amount of sea glass, so she returned the following morning. By then the piles were gone.

Ten years later, knowing that sea glass is an ever-diminishing reminder of the past, Comolli still wonders why she, and not her friends or others who regularly search for treasures, came across those two huge piles of shards.

"Was it a sign or a miracle?" she asks. "No one has ever been able to explain it, but since then walking that beach has become a ritual for me, a calming, rewarding, and engaging activity."

At her home in a converted nineteenth-century silk mill, artist Anna Coniaris Comolli displays sea glass under her glass coffee table. The cool chromatic spectrum includes fragments from rare teal-colored mineral water bottles; aqua Mason jars and telephone pole insulators; indigo ink bottles; cobalt poison and medicine bottles; Georgia green Coca-Cola bottles; emerald soda, beer, and gin bottles; celadon bitters bottles; and absinthe-colored Vaseline glass. The large yellow-ware crockery fragment (right) originated as a late seventeenth-century English mixing bowl. Today, a perfect

PAINTING WITH SEA GLASS

Abstract landscape painter Elynn Kroger placed a large bed of sea glass at the base of a display case outside her studio on Rocky Neck in Gloucester, Massachusetts, home of the country's oldest working art colony. Both the sea glass and the actual landscape reflected in the glass case recall paintings of Winslow Homer, Fitz Henry Lane, and Childe Hassam, who all painted scenes in this area.

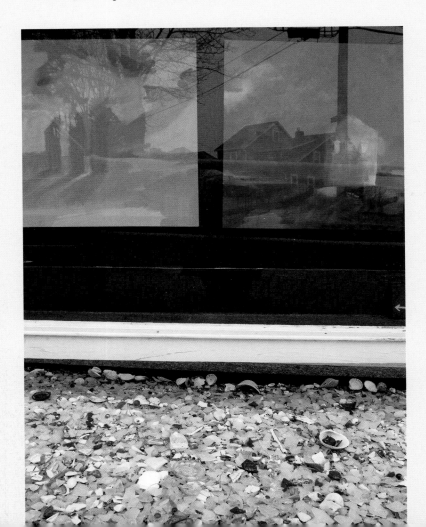

DIVINE INSPIRATION

On a small island off the coast of Maine, one sea glass collection evokes the same reverance inspired by early Gothic stained glass windows. Ashley Bryan, acclaimed artist, writer, puppeteer, and college professor, has created his own iconography through commonplace, discarded glass gathered from Islesford beaches. His inspired, monumental sea glass panels have been a work in progress since the mid-1950s.

These two large panels, each measuring three and a half feet tall by five feet wide, hang in the windows at the west end of Bryan's house. The panels portray a series of events from Jesus's life taken from the four gospels.

Like the stained glass windows of the twelfth and thirteenth centuries, Bryan's images come together in a two-dimensional mosaic of rich colors. Unlike the artisans from earlier centuries who chose the finest glass for their creations, Bryan prefers the imperfections inherent in sea glass. "The irregularities are so attractive. What would otherwise be considered a flaw becomes what makes the piece extraordinarily beautiful," he explains.

Bryan has a lifelong fascination with discarded objects. Much of the sea glass he finds originated as commonplace vessels. Clear glass comes from vintage Atlas canning jars, colors from a variety of household containers: cobalt Milk of Magnesia and Noxema, amber Clorox, emerald 7-Up, Georgia green Coca-Cola, varying shades of lavender apothecary, and ruby perfume bottles. Fragments with geometric patterns recall Depression-era pressed glass dinnerware, some with muted mossy green and salmon colors. While his sea glass panels are inspired by illuminated manuscripts and stained glass windows, Bryan has the spirit of a folk artist. He is faithful to the sentiment expressed by early liturgical arts yet adds his own interpretation and architectural arrangement.

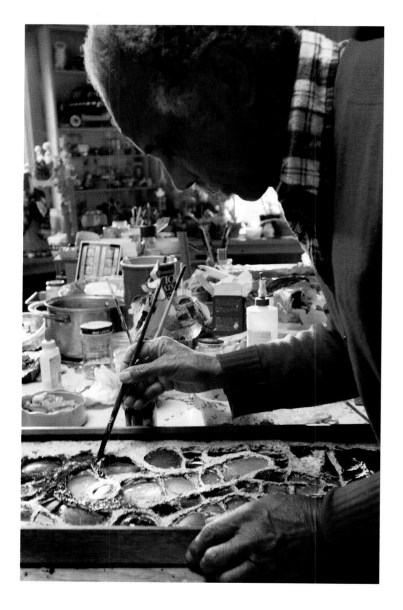

[Above] **Bryan restores the panel representing the apostle John. With minor repairs, the original sea glass panels Bryan made in the 1950s still stand strong.**

Each panel depicts five scenes from the life of Jesus. Larger renderings of the four evangelists flank the ensembles of smaller squares: Matthew is represented as the angel, Mark as the lion, Luke as the ox, and John as the eagle. Squares with floral motifs separate the scenes. According to Bryan, these floral panels were inspired by Matthew 6:28–29: *Consider the lilies of the field, how they grow; they toil not, neither do they spin . . .*

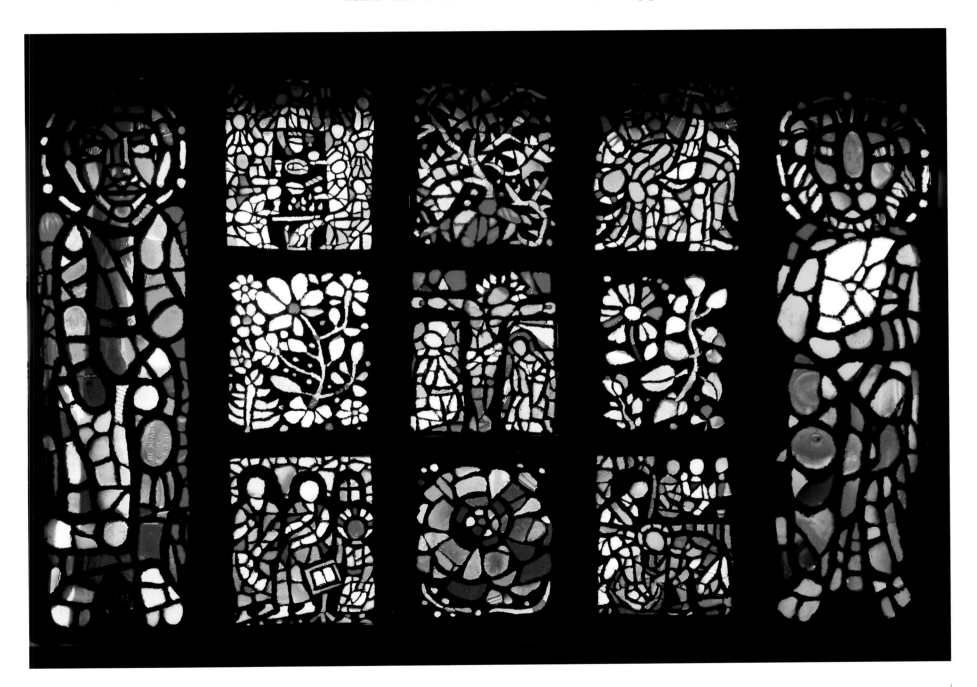

Through a variety of experiments, Bryan devised an unlikely substitute for soldered lead strips traditionally used to connect the internal framework of stained glass imagery. True to his belief in re-employing objects already in the environment, Bryan uses bits of newspaper and wallpaper paste to create papier-mâché. He points out that papier-mâché has been used throughout the ages, and he admires the "miracle of its transformation" from fragility to strength.

Throughout the day, the tableaux seem to change organically as shifting light varies the radiance of individual shards.

"The panels are always new to me," says Bryan. "They are always surprising, always a wonder. When the last light of day finally goes, the colors in the panels turn soft. It is exciting to watch the play of light until it finds its way out of the day."

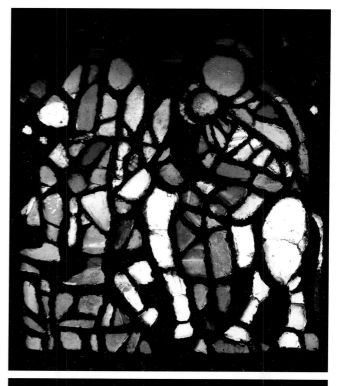

[Top] In the smaller panel depicting the flight to Egypt, the cryptic message "return" is embossed on Mary's face.

[Bottom] Bryan deciphers individual sea glass shards by color, shape, texture, and density, and arranges them in a visual metamorphosis that communicates the gospel. This panel represents Luke 2:46-47.

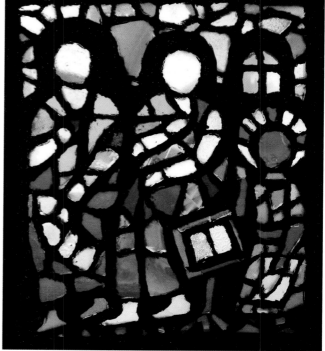

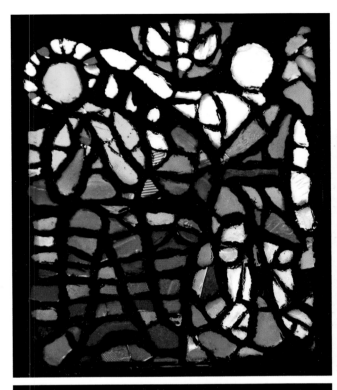

[Top left] **This panel represents the baptism of Jesus. (Mark 1:9–10)**

[Bottom left] **Here Jesus reaches out to John, who is walking on water.**

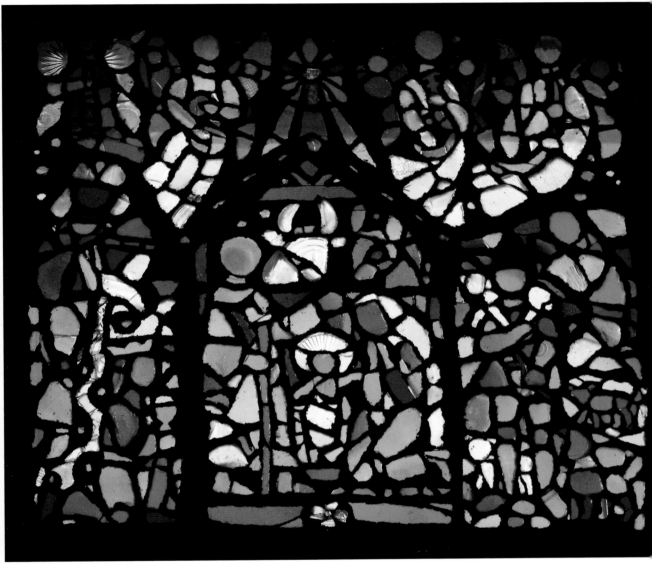

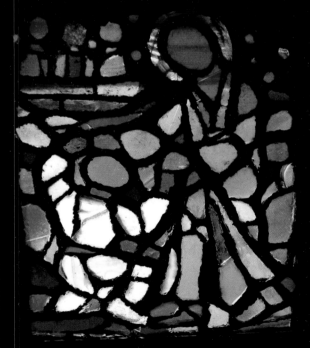

[Above] **This sea glass panel depicting the Nativity hangs high in the window overlooking Bryan's second-floor studio.**

[Top left] In a scene inspired by the passage "Suffer the little children to come unto me," Bryan depicts one of the children doing a handstand.

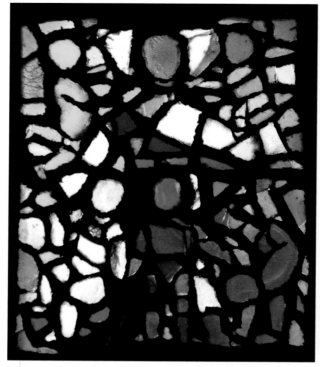

[Top right] *The Pietà*, an early Christian art term derived from Latin for *piety* and *pity*, shows the body of Jesus in His mother's arms after the Crucifixion.

[Bottom right] By incorporating shards containing letters, numbers, and truncated words, Bryan animates once-lost objects with his singular vernacular. In "The Scourging" scene, Jesus's face emerges from an unidentified utilitarian bottle fragment and reveals the prophetic partial logo "others."

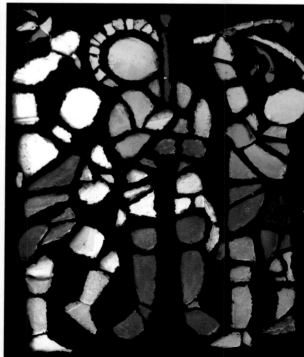

[Bottom left] This image is inspired by John 13:16, Jesus washing the feet of his disciples.

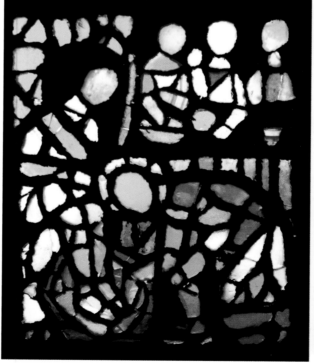

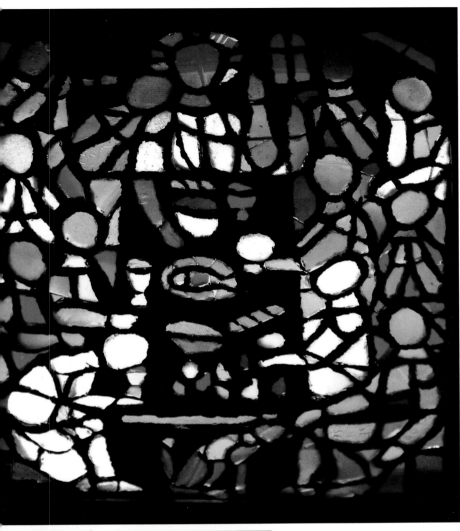

Bryan designed "The Last Supper" in a vertical format. He also placed a luminous cornflower blue dog at the foot of the table, in a nod to other Biblical references to canines eating crumbs.

CREATE A SEA GLASS WINDOW

MATERIALS NEEDED

A window frame or a picture frame

Sea glass in various colors

A piece of paper the size of your frame

A piece of waxed paper the size of your frame

Newspaper, cut into thin strips

Wallpaper-paste powder

Black paint

Sketch your desired design on the piece of plain paper. Lay the waxed paper over the sketch. Place the frame on the sketch, and arrange sea glass pieces on the paper, following the sketched design template.

Combine a handful of newspaper strips, a handful of wallpaper paste powder in a bowl, and add water a few drops at a time. Mash these ingredients to a pasty pulp.

Work the papier-mâché into the spaces between the shards and also between the glass and the inner edge of the frame, making the papier-mâché layer the same thickness as the sea glass shards.

Let the papier-mâché dry overnight.

Carefully paint the papier-mâché black.

Allow the paint to dry thoroughly before lifting the newly created sea glass window and its frame off the waxed paper.

Hang your "sea glass stained glass" in a window.

MINIATURE MASTERPIECES

Individual shards with antique images somehow resonate with beachcombers. Any combination of sky, land, water, architectural structures, people, animals, and words can trigger emotions and even seem prophetic.

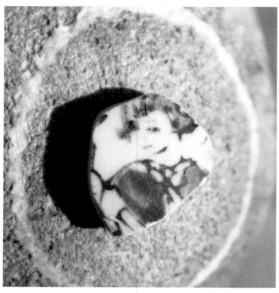

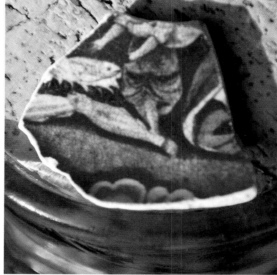

[Above] **What appears to be a partial portrait of Ludwig van Beethoven is actually a lion's head from the English Royal Coat of Arms.**

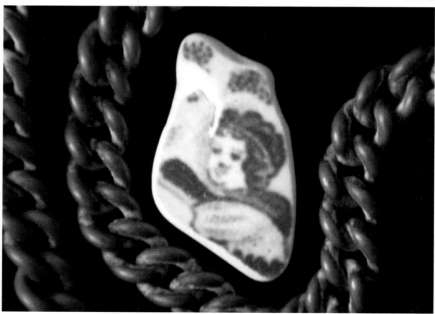

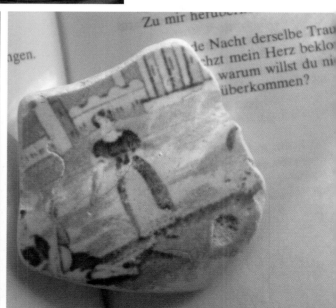

Glass or ceramic shards containing images that reveal part of a story are probably the most difficult sea glass category to find. These images can be hand-painted, etched, transfer-printed, or embossed. In addition to their singular artistic appeal, the designs often give clues to the origin. Denise Donnelly, a writer who lives in Pigeon Cove, Massachusetts, has a knack for finding these elusive fragments.

[Left and Below] Reminiscent of hinged three-panel paintings and sculptures of Renaissance painters such as Hans Memling and Hieronymus Bosch, this triptych was created by Kate Nordstrom of Alna Goods, in Alna, Maine, from pieces collected by Donnelly.

Two doll fragments: The partial torso has lost its surface glaze to the sea, while the face retains its luster because it had been wedged between two rocks and did not suffer much abrasion.

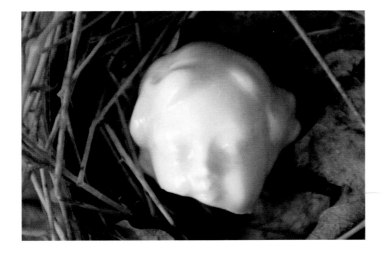

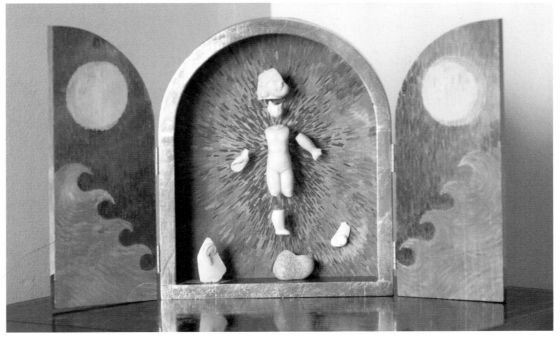

SOUL OF THE OUTER BANKS

Recognized for its historical significance to Nags Head and the Outer Banks of North Carolina, the Nellie Myrtle Pridgen Beachcomber Museum features an unprecedented collection of sea glass and ceramic shards. The museum is named after a reclusive, and some would say eccentric, environmentalist who combed local beaches for most of her seventy-four years. Pridgen's massive collection is housed in Mattie Midgette's Store, a building that once housed a grocery store owned by Pridgen's mother. The building was listed in the National Register of Historic Places in 2005 and contains countless beach-found objects organized much the same as when Pridgen died in 1992.

Pridgen's extraordinary legacy grew out of her dislike for what she considered the overdevelopment of Nags Head. A passionate defender of the environment, she became increasingly reclusive as she witnessed her fishing village of fewer than a thousand year-round inhabitants grow into a multimillion-dollar resort. As shopping centers, bridges, and roads crept closer, she built stone barriers around her property and even ostracized herself from friends and family.

Still she continued to gather the seemingly endless treasure that washed up on her mile-long beach, and created a fragmentary documentation of Nags Head before and during her lifetime. Catherine Kozak, a reporter for *The Virginian-Pilot*, called the store "more than a depot for Pridgen's cache, it is a depot of Outer Banks history and lore. Inside lies the soul of the Outer Banks."

All photos in this section are courtesy of Chaz Winkler, of the Nellie Myrtle Pridgen Beachcomber Museum.

Pridgen walked the windswept beach every morning.

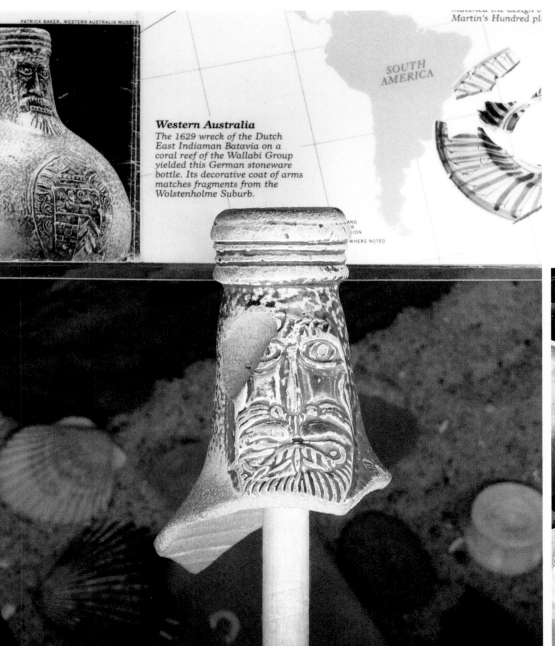

Western Australia
The 1629 wreck of the Dutch East Indiaman Batavia on a coral reef of the Wallabi Group yielded this German stoneware bottle. Its decorative coat of arms matches fragments from the Wolstenholme Suburb.

[Left] This bottleneck is part of a Bellarmine jug, a form of German stoneware that dates to the sixteenth century. One story has it that the name is a satirical reference to Robert Bellarmino (1542–1621), an Italian cardinal and saint who sought to topple Protestantism. The bearded face on the bottleneck and rounded bottle body are said to resemble the corpulent cardinal. Pridgen found this shard on her beach in the 1980s.

[Below] A large variety of bottlenecks and bottle bases are represented in Nellie Pridgeon's unique museum.

[Below] Pridgen found this spectacular sixteen-inch specimen of fulgurite, a piece of glassy rock produced by lightning-fused sand, on Jocky's Ridge sand dune. Fulgurites are generally small, hollow, icicle-shaped pieces, and are rare.

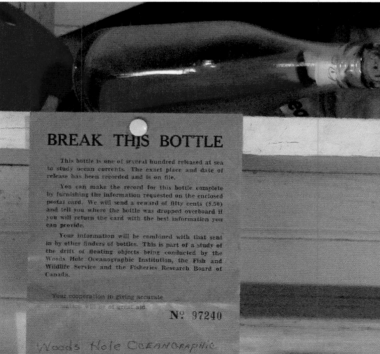

BREAK THIS BOTTLE

This bottle is one of several hundred released at sea to study ocean currents. The exact place and date of release has been recorded and is on file.

You can make the record for this bottle complete by furnishing the information requested on the enclosed postal card. We will send a reward of fifty cents ($.50) and tell you where the bottle was dropped overboard if you will return the card with the best information you can provide.

Your information will be combined with that sent in by other finders of bottles. This is part of a study of the drift of floating objects being conducted by the Woods Hole Oceanographic Institution, the Fish and Wildlife Service and the Fisheries Research Board of Canada.

Your cooperation in giving accurate information will be of great aid.

N⁰ 97240

Woods Hole Oceanographic Institution
Woods Hole, Massachusetts

[Above] A fragment from a nineteenth-century transferware plate contains the image of a tall ship in a harbor. It is not difficult to imagine that this shard might reflect part of its own journey.

[Left] This message in a bottle was sent from the Woods Hole Oceanographic Institution in Massachusetts to help study ocean currents in the 1960s.

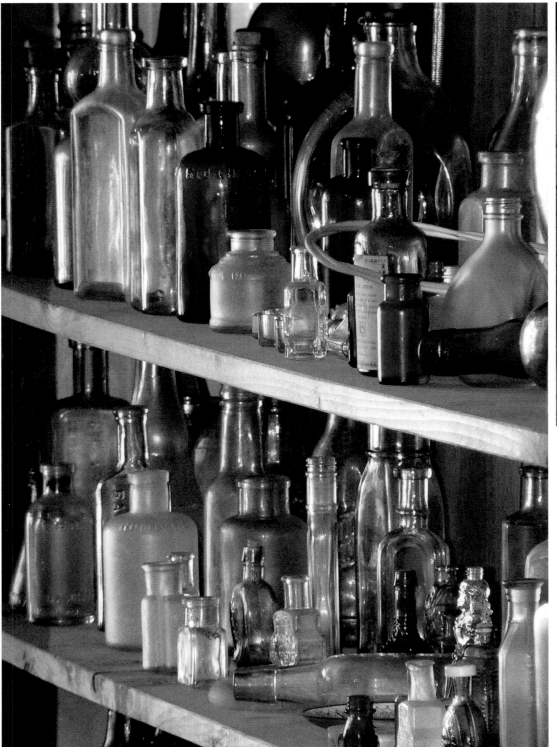

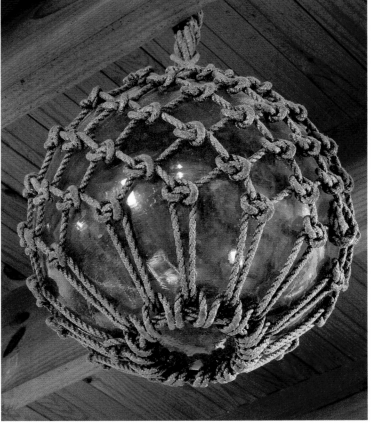

[Above] A fifteen-inch glass fishing float, which likely dates from the early 1900s, hangs from the museum ceiling. This float may have originated in Europe or the United States. Floats found on Pacific shores come mostly from Japan.

[Left] Approximately two thousand antique bottles, which once held every imaginable liquid, crowd six worn pine shelves on one museum wall. The bottles vary in size, shape, and color; some contain messages scrawled on rolled paper. Many were recovered from nearby sound-side waters where nineteenth- and early twentieth-century visitors arrived in Nags Head aboard steamers out of nearby Elizabeth City.

[Below] **This rare Dutch gin bottle bottom is more than two hundred years**

[Right] The waters off Nags Head, known as "the graveyard of the Atlantic," create a turbulent, high-energy shoreline. The area produces a distinct type of sea glass that shows coarse pitting and increased frosting caused by the salt penetration, as seen here: highly coveted cobalt sea glass, and from bottom right: a fragment from a Blue Willow plate, the bottom of a soda bottle, the square base of an early Vaseline jar, and a chunk of bonfire glass.

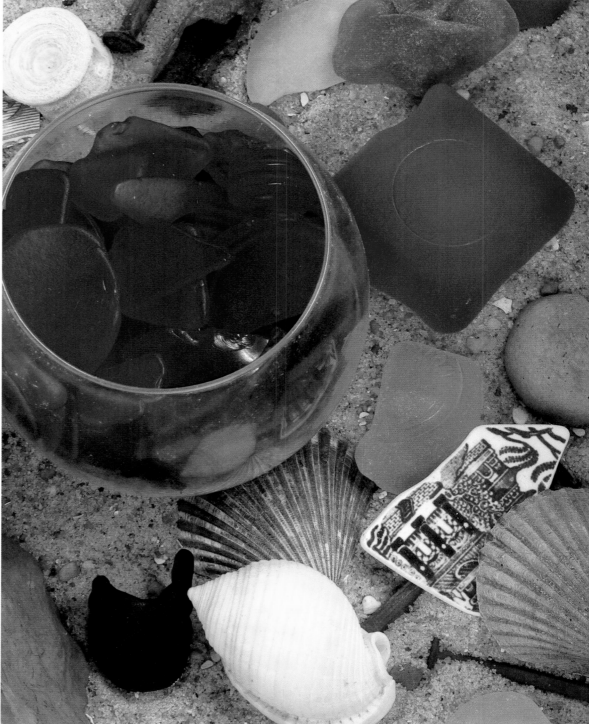

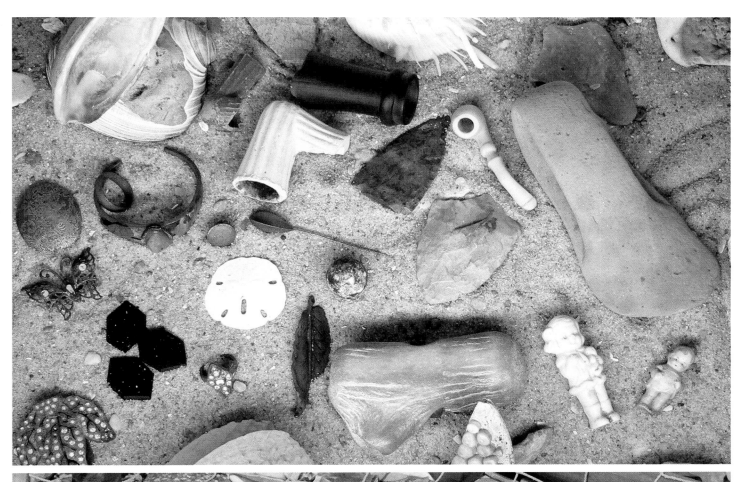

Pridgen kept her most prized pieces in a sand-filled case: a fragment of an Indian pipe (upper left corner, between clam shell and bottleneck), plus a toy pipe, two china dolls, and some Victorian jewelry.

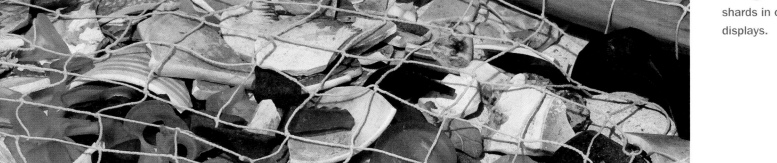

Fishing nets cover the loose shards in one of the museum displays.

THE EBB & FLOW

It is difficult to imagine any sea glass collection as comprehensive as the one belonging to Jill and Pete Litrocapes of South Portland, Maine. They have integrated what appears to be every sea glass category imaginable into their home in an eminently touchable manner.

Small and large piles seem to crop up everywhere alongside sea glass candles, mosaics, sun catchers, and in display cases. But none of this gives the impression of clutter. On the contrary, the huge amounts of sea glass create a serene, organic environment.

"Fifty years ago, as a child, I spent endless days on rocky coasts and beaches with my eyes looking downward," says Jill Litrocapes. "Today, as I still do the same, I have discovered a deeper appreciation for everything through the meditative exercise of searching for special pieces. I am awestruck by the history that unfolds with a tiny shard and how it connects the possibilities of so many human beings, from maker to user to discarder, and how it made its way to my hand via the ocean, where we all came from."

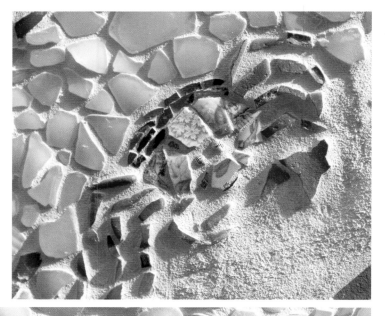

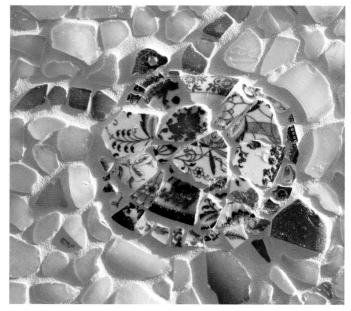

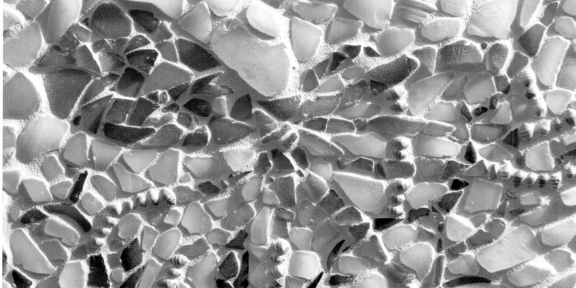

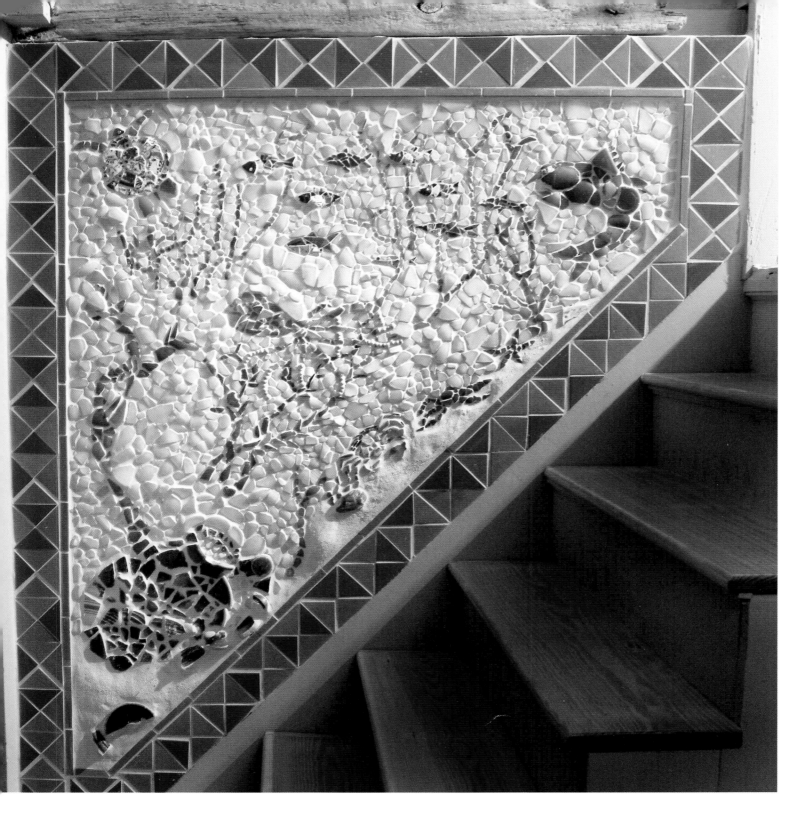

Jill Litrocapes created this "Underwater Mosaic" on a stairwell wall. It depicts the movement of sea creatures when the squid, in the center, comes out of an ancient urn. Notably, the squid was made from rare lavender shards with a ruby sea glass eye.

[Opposite] The shape, color, and combination of ceramics and glass were carefully chosen to add life to the narrative.

The Ebb and Flow | **65**

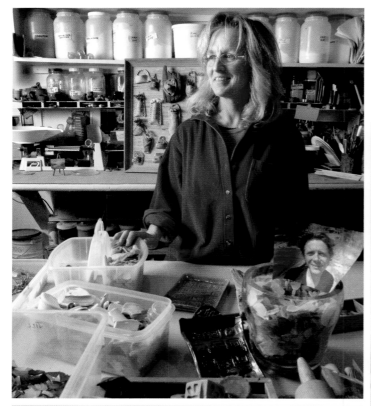

[Left] **Jill Litrocapes** is surrounded by sea glass and ceramic shard projects. A photograph of her husband Pete stands in a bowl of shards.

[Below] **The potting shed is overflowing with shards.**

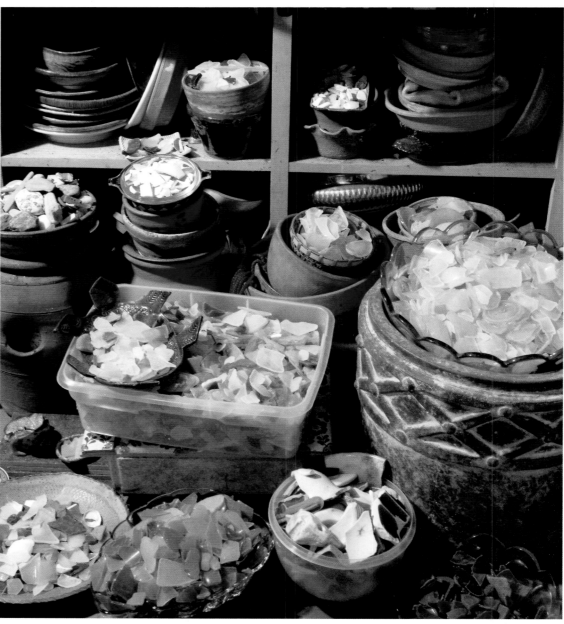

[Above] **This painting by Jill's grandfather hangs in her living room. It depicts a beach in Marblehead, Massachusetts, where she first found sea glass as a child.**

[Left] Live turtles bask in the winter sun in the sunroom, where a continuous shard mosaic borders the top edge of the room.

[Below] An early crockery batter pitcher handle and crockery fragment with the number 2 are rare pieces placed in the sunroom border.

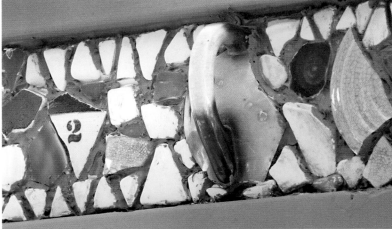

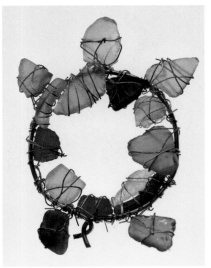

[Above] This sea glass turtle sun-catcher is a tribute to the ancient fellows in the sunroom.

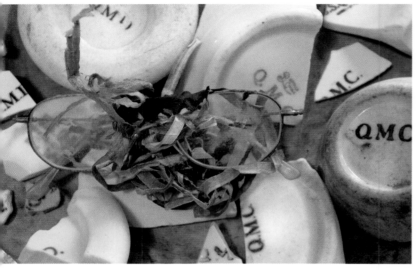

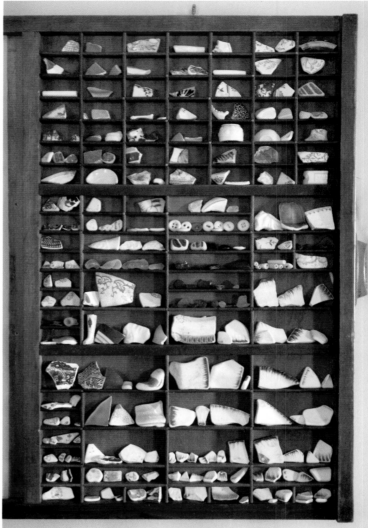

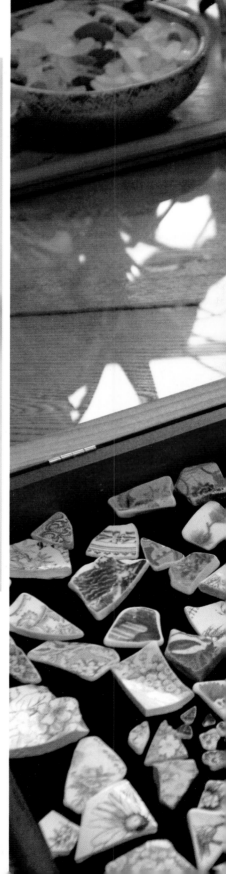

A METHOD TO THE MADNESS

Many beachcombers develop their own hunting methodology. Some scan the beach in a zigzag pattern, some walk forward and backward, keeping their backs to the sun and wind at all times. Some carry a stick to flip objects over before bending down to examine them further. Others sit on the sand and rake the surface with a hand-held garden hoe.

Jill and Pete Litrocapes use a specialized sea-glunking tool: kitchen tongs. The long, hinged aluminum arms extend their reach. Most important, the tongs keep their gloved fingers dry, permitting them to venture out when even the most ardent collectors draw the line—at near-freezing temperatures.

[Above] Antique lead type trays filled with fine examples of sea glass and ceramic shards hang throughout the house. The lower right quarter of this tray holds some of the oldest pieces in the collection: Leedsware, also known as shell-edge, manufactured in Leeds, England, from the 1700s.

[Right] A glass case in the front room holds some of the couple's finest treasures: ceramic doll fragments, Victorian transferware, and apothecary bottle stoppers.

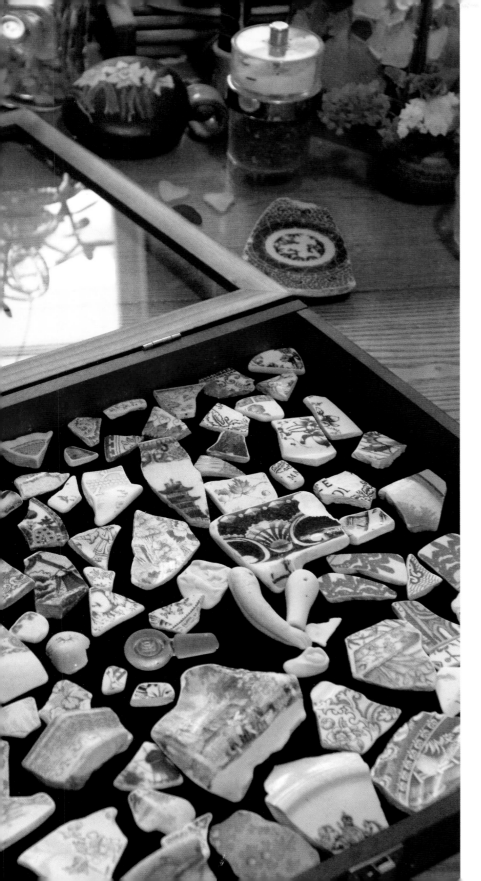

CREATE A SEA GLASS FLOATING CANDLE

MATERIALS NEEDED

Clear glass vase

Sea glass

Water

Liquid bleach

Lightweight votive candle that will float

Arrange the sea glass pieces in the vase. Fill the vase to within two inches of the top. Add a capful of bleach to the water to keep it algae-free. Float the votive candle on the water.

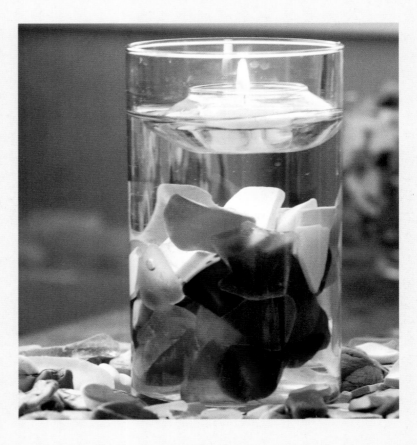

SEA GLASS ALCHEMY

When Lynette L. Walther finds a piece of sea glass, she asks herself, "What would a mermaid do with this?" Walther, a writer and artist, spends summers in coastal Maine and winters in coastal Florida, and a good deal of her time is spent beachcombing.

"I am a treasure hunter to my core," she says. "I dream about finding riches. And what could be more valuable than something for nothing, little jewels tossed up by the sea?"

Walther fashions sea creature sculptures, which she has named "Arti-Facts," from frosty sea glass, china shards, shells, and other shoreline oddities. She says they represent organic beings made from inorganic materials, ordinary objects that have been altered by the sea. "It's a perfect alchemy," she says.

For those who question the value of sea glass hunting, Walther offers this anecdote about an unexpected additional treasure she found while collecting sea glass on a recent trip to Costa Rica. She and her husband were combing the coral beach at Puerto Limon when they found a tiny purse in the sand. "It was soaked, and probably washed up with the tide," she recalls. "Inside was a roll of soaked bills, which totaled sixteen thousand *colones*!"

This bundle of cash converted to approximately thirty-two U.S. dollars, which bought the Walthers a pottery vase and a battered Costa Rican car license-tag to add to the family's collection. "We traded the rest to our taxi driver for the coins in his pocket, possibly a ten-to-one exchange in his favor."

[Top] Award-winning garden writer Lynette Walther finds similarities between her favorite pursuits of making sea glass creations and cultivating her garden: both provide satisfying work with nature's creations. (Courtesy of Captain Bob Walther)

[Bottom] A close-up view reveals how intricately Walther wraps the fine wire to link glass and ceramic shards together. Irregularities such as the tiny barnacles on the piece of milk glass in this photo add to the uniqueness of each Arti-Fact.

CREATE AN ARTI-FACT

MATERIALS NEEDED

Large piece of cardboard

14-gauge aluminum wire

20- or 24-gauge craft, copper, or other wire

Assorted pieces of sea glass, china shards, shells, etc.

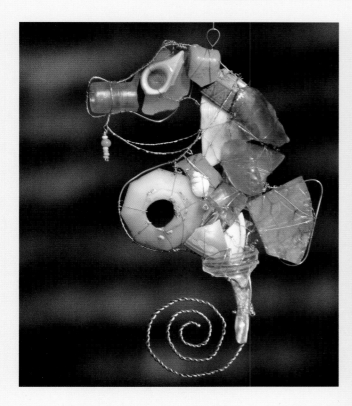

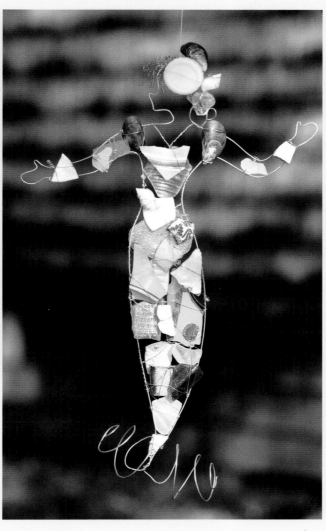

Draw an outline of the figure on a piece of cardboard. Bend the 14-gauge wire to match the outline.

Lay out sea glass and other items on the outline on the cardboard, filling in as desired. Use the craft wire to attach pieces to the frame of aluminum wire.

Attach a hanging loop at top.

WEARABLE ART & HISTORY

Jacqueline Ganim-DeFalco equates hunting for sea glass with the storyline from the 1998 movie *The Red Violin*, written by Don McKellar and Francois Girard. The film, inspired by the true story of a Stradivarius violin created in 1720, traces the history of one instrument and its owners across five continents and three centuries.

"That's how I think of sea glass and pottery shards," Ganim-DeFalco says. "It's easy to get lost in the hunt for hours and think about what it took for this fragment to find its way to where it landed. The journey the object took and the lives it touched are part of its appearance."

Ganim-DeFalco moved from New York City (via Hong Kong, Dallas, Atlanta, and Boston) to a home overlooking a cove rich with sea glass in Gloucester, Massachusetts, in 1994. Nine years later she combined her career as a marketing advisor with her newfound passion for beachcombing and created a business that suited her new lifestyle.

"I realized that there was real history in the large quantities of sea glass I had been gathering in jars throughout my home," she says. "I wanted to create something from treasure indigenous to the Cape Ann area."

Thus her business Cape Ann Designs, hair accessories and brooches made with sea glass and ceramic shards, was born. "Sea glass revived my creativity, which I felt had been temporarily lost to corporate America," she adds.

Ganim-DeFalco and her husband, Michael, share a mutual passion for history and antique–glass collecting, and sea glass proves to be a natural extension. She enjoys telling her metropolis-based friends that much of her gainfully employed time is spent walking the beach with Michael.

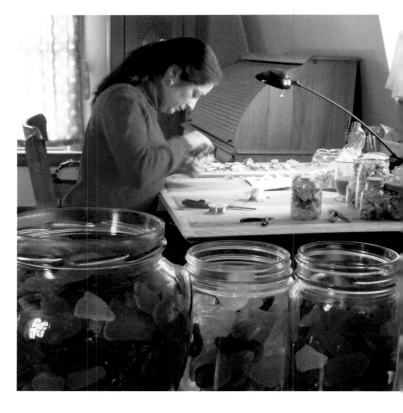

[Above] Jacqueline Ganim-DeFalco works in her jewelry studio surrounded by jars of shards sorted by color, size, and shape. These ever-scarcer gems are about to start a new life as wearable art.

[Opposite] These hair combs, picks, and sticks were inspired by an ancient Egyptian art form—*wire wrapping*.

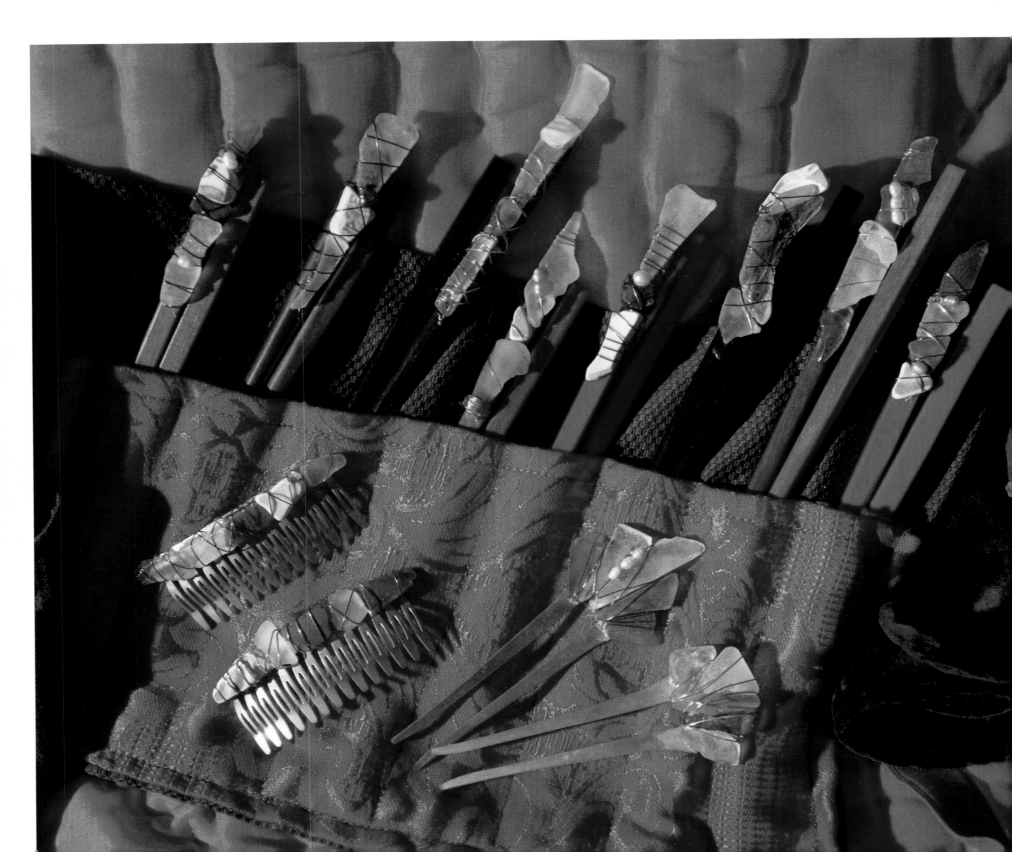

[Right] Challenged by unusual shapes that can't be used in her hair pieces, Ganim-DeFalco started creating "glass-on-glass" brooches, tie tacks, and hat pins. She adds new pieces (bolos, pendants, earrings) to the collection based on feedback from friends and galleries that show her work.

[Below] This exceptional ceramic shard originated as a mid-1800s transferware calendar plate. The the central group of numbers represents the month of February.

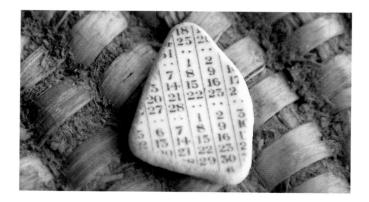

FASHION-RELATED SEA GLASS

Donna Karen has a personal collection of jewelry created from Israeli sea glass.

J. Crew created a Sea Glass perfume.

Cover Girl Cosmetics makes Sea Glass eye shadow.

Calvin Klein used sea glass rings—antique bottle lips broken perfectly at the aperture— in his 1993 spring collection.

Virginia Woolf wrote the short story "Solid Objects" in 1944 about a man's life and career taking a lugubrious turn when he finds a single piece of sea glass that he imagines might easily be turned into a piece of jewelry.

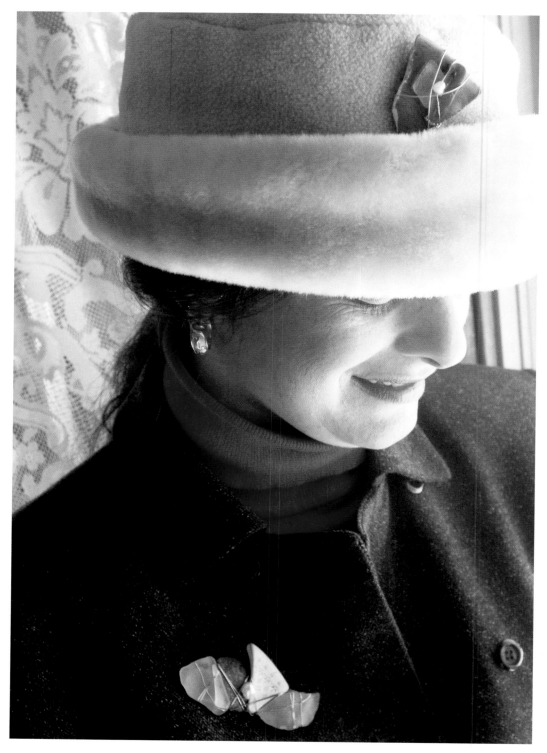

[Left] A line of bridal hair accessories uses lighter shades of glass and pottery.

[Below] "I look for specific sizes, shapes, colors, and textures. I visualize a series of puzzles and try to imagine how these pieces will naturally fit together to form a unique piece of hair art or an eye-catching brooch."

GARDEN METAPHOR

Sandy Whitney is passionate about working in his garden, searching for antiques, and combing New England beaches. These interests converge in a small, spectacular flower and vegetable patch where history is reflected in his meticulously coordinated sea glass mulch.

"This garden has been a long time in the making," says Whitney, a Maine hospital materials' manager. "Fifteen years ago, while beachcombing on a frosty winter day, I met the woman I would later marry. From the first day we met, we combined our beach treasures, and this became the foundation for our garden we created this summer." Since then the couple have moved six times in Massachusetts and Maine, where generations of both families have lived, and where they continue to collect sea glass.

"While it is nearly impossible to know how or why an individual shard washed up on a beach where I found it, I can't help but feel the archaeological connection to my ancestors and how they lived.

"Most pieces of sea glass are old enough to be considered antiques, which by the American standard is fifty years or older. Sometimes at an auction or estate sale I am able to identify the age and whole object that the sea glass or ceramic shard originally was.

"By using sea glass as mulch, I feel that I'm somehow perpetuating the past into the future by placing these bits of history in a living, growing environment. Of course this takes a lot of patience and a lot of sea glass.

"For me it's all about the hunt—an unusual antique, a tomato plant different from others I've grown, or a piece of rare-colored sea glass."

Whitney chose large pieces of ocean- and sky-colored sea glass and ceramic shards for his garden mulch. As attractive as it is unusual, this mulch will drastically reduce the amount of time spent weeding, watering, and fighting pests, as well as keeping dirt from splashing up on flowers and vegetables when it rains.

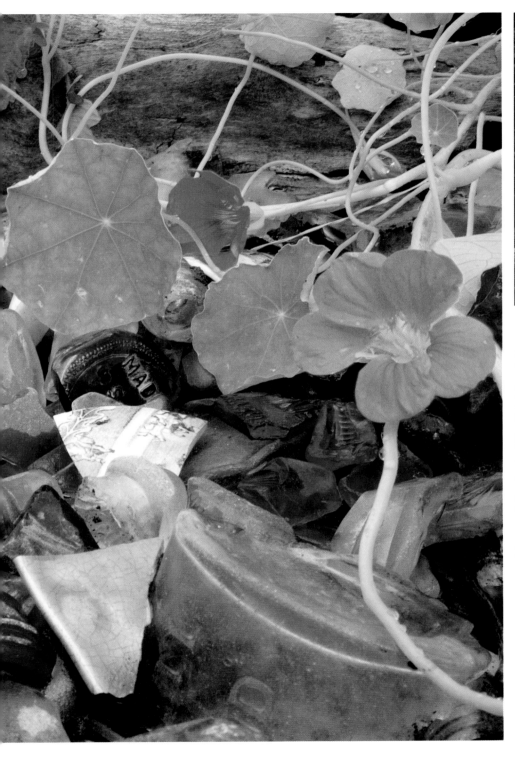

Found in the harbor at Wiscasset, Maine, this pipe bowl is made from hand-carved meerschaum stone. Appropriately, in the case of this rare bit of flotsam, the German word *meerschaum* means foam of the sea. The intricately designed face of Queen Victoria dates this piece to the mid-1800s to early 1900s. During its mysterious voyage it became discolored by ocean pollution, and evidence of barnacles that once lived on the pipe's surface appear as jewelry in Victoria's hair. This fragment is the pride of Whitney's collection.

CREATE A GARDEN WITH SEA GLASS MULCH

Large pieces of sea glass work best. In this garden, shards average from one to two and a half inches across.

Clear a garden area proportionate to the amount of sea glass available, removing grass, plants, and debris.

Cut landscape fabric to cover desired garden area. Determine plant arrangement, and cut openings in the fabric where the plants will go, making holes a half-inch wider than the plants' roots.

Dig holes for plants, lightly pressing each plant into its hole and making sure the top of the root ball is flush with the ground. Water in.

Cover the fabric with sea glass and pottery shards, arranging pieces close together or slightly overlapping.

In time, as the plants expand at the base, carefully shift the sea glass outward so it won't inhibit plant growth.

After the first frost, gather up the sea glass and pottery shards, soak them overnight in mild bleach solution (1 capful bleach to 1 gallon water), rinse, dry, and store until next spring planting.

PANELS OF LIGHT

Throughout Nick Sturtevant's house and guest cottage, shards are organized in a variety of containers. Some are set aside in a place of pride due to their rarity; others are set out like tin soldiers marching across a ledge.

This sea glass environment evolved over the past seven years and has become the grounding force for Sturtevant, who lives in Rockport, Maine. After a twenty-three-year career in healthcare administration, Sturtevant opened his own landscape gardening business. He is never happier than when he is on a beach, and he walks the coastline daily in search of sea glass. He calls it a meditative experience.

[Top right] Nick Sturtevant sorts through a copper bucket filled with shards. Some of his more unusual sea glass finds, such as tiny porcelain feet, antique bottle lips, and a ceramic dinosaur rest on the kitchen windowsill.

[Opposite and right] An eight-foot-long window panel at the top of the stairwell serves as a privacy screen while allowing filtered light to shine through. The informal mosaic effect was created by dropping shards, one by one and without glue, between the double panes as the window was assembled.

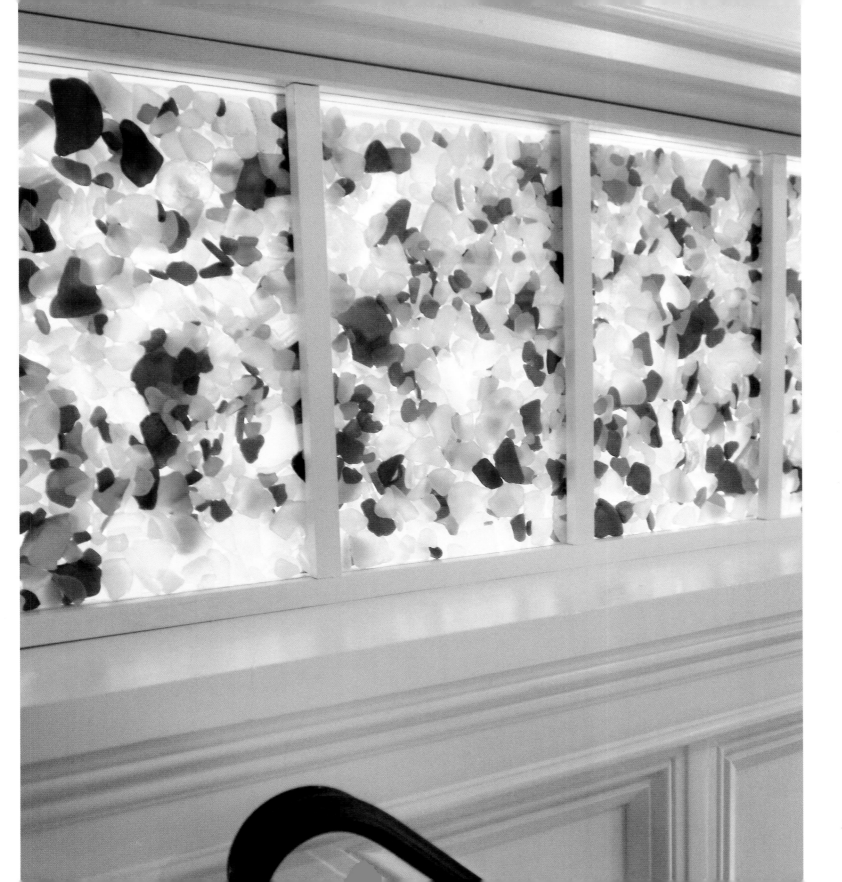

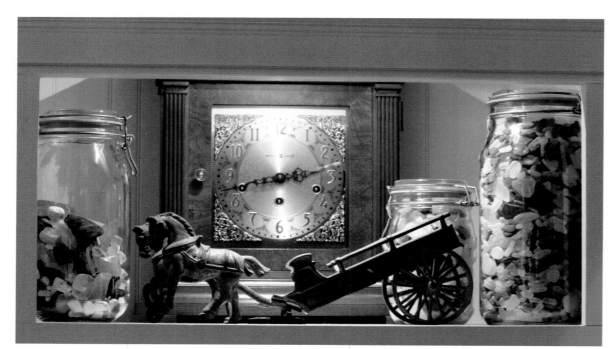

[Above] **Prized because they are worn fragments of vintage objects, the shards in canning jars provide a pleasing contrast when displayed with antiques that are in perfect condition.**

[Right] **Resembling a cluster of tiny planets, antique marbles cast elliptical shadows on a fossil-embedded stone. The two turquoise orbs are extremely rare due to the difficulty in achieving color consistency during production. Copper or iron added in small amounts to a raw glass mixture containing cobalt will result in turquoise, but color uniformity is hard to come by because of the cobalt's density.**

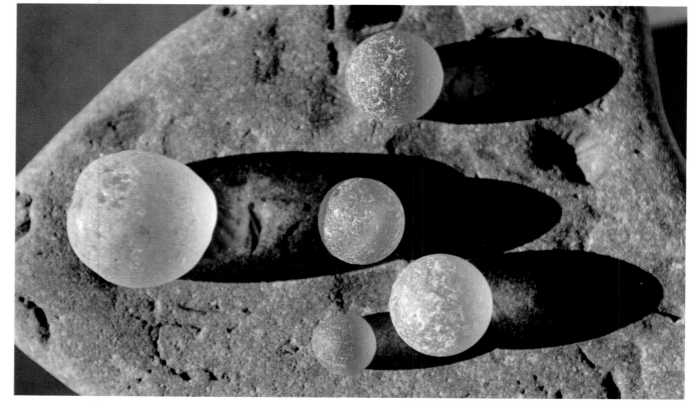

[Above] Sturtevant frequents several beaches where he finds large pieces of sea glass such as vintage insulators, which came into use on telegraph lines in the 1840s. The aqua insulator in Sturtevant's hand weighs three-quarters of a pound. The amber shard came from an early twentieth-century Clorox bleach bottle. The slightly collapsed bottle fragment on Sturtevant's finger was partially melted—probably in a coastal dumpsite fire—and retains sand and pebbles that became embedded in the softened glass. (Such molten shards are called, prosaically, bonfire glass.) The pale yellow shard was manufactured between 1915 and 1930, when selenium was added to glass; prolonged sun exposure turned the originally colorless glass to this bland straw tint.

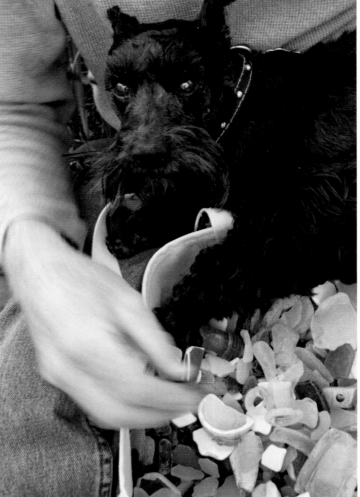

[Above] Most of these eighteenth- and nineteenth-century bottle stoppers once kept apothecary medicines from evaporating. The decorated lavender pressed glass stopper in the center belonged to a perfume bottle.

[Left] Max, Sturtevant's miniature schnauzer, plays in a month's worth of collected sea glass.

DIVING FOR TREASURE

Rick Carney of Brunswick, Maine, dives year-round in search of sea glass. What began as a land-based, childhood bottle-collecting hobby has evolved over three decades into a full-blown avocation. In his spare time, when not working as a photocopier repairman, Carney searches both fresh- and saltwater venues along the East Coast for whole antique bottles as well as glass and ceramic fragments.

Aspects of Carney's sea glass collection pervade his work and living space. His garage houses dozens of fish buckets full of sea glass in various stages of cleaning. He soaks bottles that are in perfect condition in muriatic acid to free the surfaces of barnacles and other aquatic growth. One workshop is dedicated to making stained glass windows and lampshades from sea glass. In a second workshop filled with photocopy machines and parts, sea glass crowds the windowsills, bookshelves, tables, and desks.

Throughout his home, antique and modern bookcases display Carney's finest treasures—rare bottles, unusual fragments, and sea glass creations. His office contains reference materials and specimens set out to be identified, and, in the basement, hundreds of thousands of pieces of sea glass fill every manner of container, creating an atmosphere of organized jewel-toned chaos.

Carney estimates that he pulls up eight hundred pounds of sea glass a year from his diving trips. He regularly exhibits his finest, perfect sea glass bottles at national bottle shows.

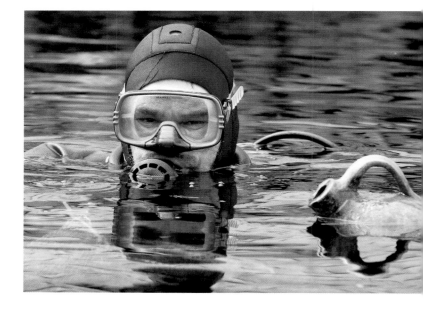

[Right] The fine detailing in this shard is consistent with nineteenth-century potteries in Staffordshire, England. During this period, novelty figurines such as this fanny dish offered a bawdy jab at proper Victorian society. The figurine was probably used as a small dish and displayed in the parlor. When nosy guests turned the object over to approve or disapprove of the manufacturer's name, they would be surprised by the figurine's bottom.

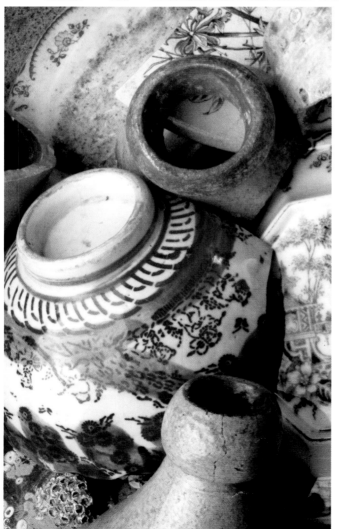

[Top and bottom left] A fractured "Rebecca by the Well" pattern Bennington teapot, circa 1840; several clay pipes from the 1700s; an American 1920s hotelware dinner plate; a hand-painted bowl, probably from Europe; an English rectangular dish lid with an Oriental motif from the mid- to late 1800s; and a redware flagon, from the 1790s, with a bullet hole in it.

[Top right] A Hamm's Mustard bottle, covered in purple coralline algae, is flanked by barnacle-encrusted sea glass. To the left is a cobalt blue jar or bottle bottom.

[Below] Because there is less wave motion in deeper water than on a beach, three of these four china dolls' heads retrieved by Carney during his dives still retain their hand-painted details, as well as their noses.

The largest is German, the two smallest are English, and all are from the mid- to late 1800s. The google-eyed doll's head dates from early twentieth-century America. Also in this grouping: a corset-shaped whiskey flask, a china sheep, an Oriental figurine, and part of a child's tea service.

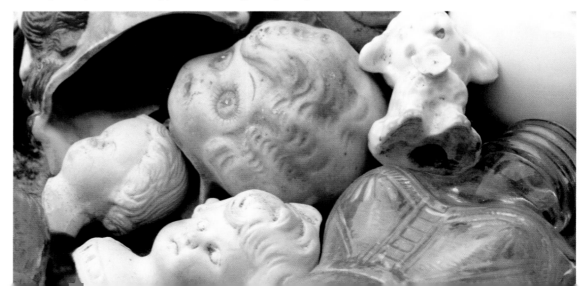

Carney, a self-taught artisan, created these Arts and Crafts–style lamps. From left to right: The wavy-ridged gold and amber sea glass shards originated as Drake's Plantation Bitters bottles. The middle shade is composed of Westford Sheaf of Wheat flask fragments, from Westford Glassworks in Westford, Connecticut. The last shade is a mixture of Stoddard Bitters, Pinetree Cordial, and Monk's Old Bourbon Whiskey bottle fragments. Early nineteenth-century American glassmakers created historical flasks celebrating patriotic themes, typically national emblems and portraits of presidents or other famous people. Both the glassmakers and distilleries profited enormously from these whiskey-filled half-pint, pint, and quart flasks.

[Right] Set in a starburst pattern of recycled glass, this half-pint sea glass bottle has an embossed American eagle above "Stoddard, NH," which is consistent with production in the early 1800s.

[Far right] Two sea glass pint-bottle fragments are set into a leaded stained glass window made from recycled glass. The amber half-pint bottle on the left was made in Westford, Connecticut. The olive–green flask depicts a cornucopia, or horn of plenty, one of the earliest historical designs, used in more than thirty patterns.

CAPTURED TEARS

Few sea glass treasures speak as profoundly as Victorian tear catchers. Also known as tear bottles, unguentaria, and lachrymatory, these vials represent both a symbolic and a tangible link to sadness and grief.

During Roman times, the bereaved shed tears into small bottles, sealed them, and buried them with the dead. In the Victorian era, tear catchers contained stoppers that allowed tears to slowly evaporate. When the last of the liquid was gone, the mourning period was considered at an end.

Documents from the Civil War reveal that women saved their bottled tears during their husbands' absences. The amount of liquid in the bottle was equated to the wife's devotion. Historically, tear catchers have also been passed through generations as tokens of remembrance.

Since our body fluids, including tears, are believed to contain salt and other minerals in concentrations matching that of the primordial oceans, it seems eerily apt that these tear catchers should end up as sea glass.

The three tear catchers in this collection measure about four and a half inches long. The first bottle is etched and decorated with gold leaf. The hand-cut spiral-cut bottle carries a ground finished neck. The rarest of the three, the cobalt bottle, has ground finger indentations and a pontil base.

These nineteenth-century spiral-cut, layered rings, and cathedral-shaped bottles once contained pepper sauce, a handy ingredient to cover the flavor of tainted meat. The open-neck jar on the left is a Hilton's Fruit Jar, dated 1868, one of a thousand known to exist.

BITTER TAXES

A good many eighteenth-century bottles contained bitters, a libation that became popular when England's George II levied a tax on gin in the mid–1700s. In order to avoid paying the tax, gin manufacturers created a so-called medicinal liquid and labeled it Bitters, Coltick Water, and Gripe Water—basically gin with added herbs.

In Colonial America, the Revenue Act of 1862 taxed proprietary medicines such as bitters, but the liquor tax was substantially higher. No doubt, many drank bitters for medical reasons, but bitters sales generally soared when gin began masquerading as medicine.

A retired physician from Pennsylvania convinced the government during the Civil War to supply troops with Dr. J. Hostetter's Celebrated Stomach Bitters, which contained 47 percent alcohol. One Pittsburgh historian noted, "Hostetter's vaunted remedial properties were sadly lacking, but many a frightened Yankee at Gettysburg knew he faced Pickett's Charge as bravely as he did because of a swig of Hostetter's under his belt."

[Right] In the twenty-five years that Carney has been diving for bottles, he has found several that carry his family name. M. Carney & Company of Lawrence, Massachusetts, sold soda and spirits at the end of the nineteenth century. According to Carney, the bitters pint bottle, in the middle, is one of only sixty-six known to exist.

[Above] When he dives in calm, protected waters, Carney sometimes finds unbroken bottles. Such whole specimens are highly desirable collectibles in their own right and are also fascinating to seaglunkers as examples of where their treasured fragments originated. Second from left, the square bitters bottle is the rarest of this group. The large one at the far right, a utility bottle, contained a cleaning agent.

DOUBLE THE POSSIBILITIES

Like many passionate collectors of sea glass, Michael and Thomas Vaiarella of Magnolia, Massachusetts, started collecting at an early age. Remarkably, they ranked among the most knowledgeable of sea glass collectors by the time they were in the second grade. That year—2004—the twins attended their first Northeast Sea Glass Festival.

Thomas remembers some of the high points of that event: "I liked how people walked up to us and asked questions about our glass and ceramics. When Michael raised his hand during Mr. LaMotte's lecture and said he had a heart-shaped piece of orange sea glass, everyone gasped!" His brother adds, "Walking around the show was fantastic, seeing everything. Having people come to our table and talk about our stuff was a blast. I remember being interviewed for the local cable news, and that was amazing, too."

A visiting aunt first got the boys interested in collecting sea glass when she told them how she used to hunt for beach treasures as a teenager in Gloucester. "First, we picked up every piece of glass we found," recalls Michael. "Then, as we learned about sea glass, we got more picky and began to look for really smooth and best-of-the-best pieces. I love to call my aunt in Florida and tell her what good glass we find—she is so jealous that she does not live here year-round."

Thomas found that he has a particular talent when it comes to beachcombing: "I am especially good at finding marbles. Once my mom told me and Michael to see who could find a marble first, and within three feet of where I was standing I found a clay marble on the ground."

This hand-painted fragment probably originated as a German child's dish or bowl decorated with a nursery rhyme illustration.

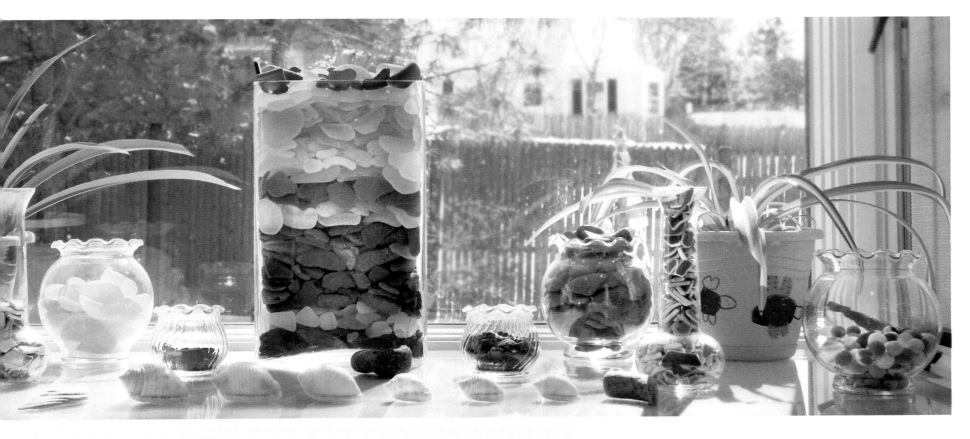

[Above] The Vaiarellas' kitchen window on this snowy day is a reminder of the colorful treasure waiting just down the road.

[Left] Michael, left, holds pink-colored glass dating between 1915 and 1930, and Thomas, Jr., right, shows off a red shard, possibly from a Victorian-era lamp.

Students in Michael's second-grade class were treated to an outstanding event one day: "I brought in a lot of my spectacular glass for show-and-tell. I brought in reds, clay marbles, bottle stoppers, doll body parts, and specially designed pottery. I also brought in your book [*Sea Glass Chronicles*] and Mr. LaMotte's [*Pure Sea Glass*] and used them as a guide to help show the other kids how my glass matched what was in the books." The next year, the teacher invited him back to present the show to her next class of second-graders. "At the end of the school year, I gave my second- and third-grade teachers big bottles of sea glass I'd collected, and they loved them!" says Michael.

Asked what was their best sea glass collecting moment, Thomas answers, "When I found my piece of orange." Michael says it was "When I found my big, beautiful, smooth red piece." For the boys, as for sea glass collectors of any age, the thrill of a great find is enhanced when it's shared. Says Thomas, "I like it when you bend down and find a really nice piece of glass or ceramic and show it to your family."

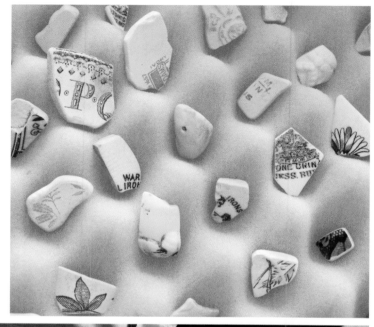

[Top] The lettering and floral patterns of these ceramic fragments show that most originated as nineteenth-century English transferware. Partial words offer clues to the manufacturer, the production date, and the pattern name. The largest piece, near the top left, clearly reveals the letter P, indicating that it once belonged to the border of a Victorian ABC plate, intended to both entertain children and teach them the alphabet.

[Bottom] The twins sort part of their collection in foam-cushioned boxes. From top left: a few favorite large ceramic pieces; rich sea glass colors, mostly heart-shaped; deep green to "black" sea glass including bottle pontils, apothecary bottle stoppers in green and amber; some rare sea glass colors including red, orange, pink, and yellow.

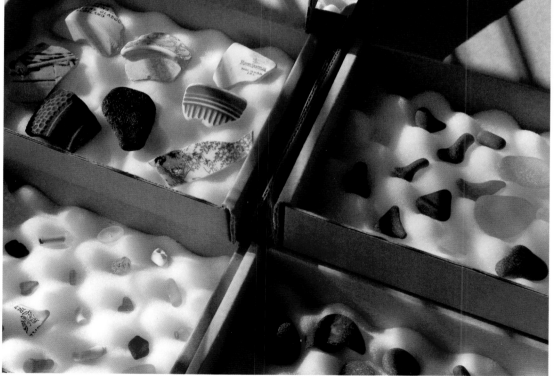

[Below] Thousands of pieces of sea glass surround an oriental ceramic pot in a living room corner.

[Above] Held against the light, this piece of sea glass reveals its true olive green color, but on the beach such glass can appear black.

[Above] A frigid day doesn't keep the Vaiarellas from their favorite pastime.

[Left] The Vaiarella twins will tell you that things aren't always what they appear to be. Bearing a striking resemblance to stones, these slate-colored objects originated between the 1700s to late 1800s as medicine and spirit bottles. Iron slag, a key ingredient in the manufacturing process, added the deep green, almost black color that protected the bottles' ingredients from sunlight. The additive also created stronger than average bottles, and as a result, sea glass derived from them is generally large. These shards average two inches in length.

THE PAST EVER-PRESENT IN THE FUTURE

"My hope is one day many will consider sea glass as a symbol of healing," says Richard LaMotte, author of *Pure Sea Glass* (Chesapeake Seaglass Publishing, 2004). "What was once shattered or discarded becomes more glorious than its original form. And in the right environment, time can heal even the deepest wounds."

LaMotte and his wife, Nancy, were casual collectors until 1999, when Nancy launched a line of fine sea glass jewelry. They then began seriously combing the Chesapeake Bay shores near their Maryland home in search of glass shards. As Nancy's jewelry designs became successful, the LaMottes became avid sea glass collectors. Soon they discovered beaches where they could collect 150 pieces in less than two hours.

The more shards they found, the more LaMotte became intrigued by the origins of the glass. He began several years of research into the history of glass, and at the same time began reflecting on peoples' emotional connection to sea glass. For him, as for many sea glass collectors, the hunt had became a therapeutic passion.

"People began revealing very personal stories about sea glass they had found while beachcombing on a very specific day. Often they had just suffered a great tragedy, and these little shards provided some form of inspiration or hope. In some cases it was some lettering on the glass, or a significant color, but in each instance they felt a bit of magic at work.

"Nature has a way of improving so many things left in its care, but a great piece of sea glass can strike awe in anyone. Each piece has its own unique history and mystery, so learning how to decipher the clues in sea glass can be quite rewarding."

"I kept hearing the same questions repeated regarding the subject of what the sea glass was originally, and how it developed its luster," recalls Richard LaMotte. "This prompted me to probe much deeper into the glass industry." (Courtesy of Nancy LaMotte)

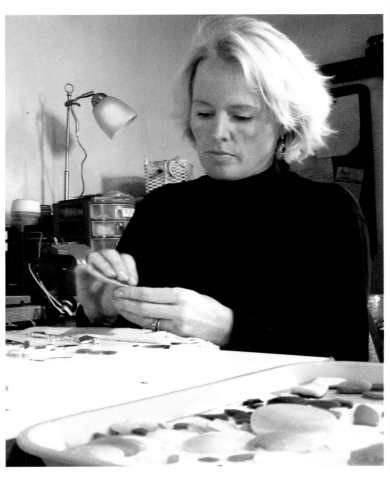

Nancy Lamotte works in her studio. (Courtesy of Richard LaMotte)

This small table was a gift from Nancy's mother, who created its mosaic top from Chesapeake sea glass. (Courtesy of Nancy LaMotte)

[Right] A three-shard bracelet features colors of the early twentieth century. The soft lavender is a noteworthy piece dating from before 1915, when manganese was used to create clear glass. Exposure to sunlight slowly oxidizes the manganese, providing this soft purple hue. (Courtesy of Nancy LaMotte)

[Below] In Nancy LaMotte's jewelry studio, sea glass is sorted by color and spread on cafeteria trays. The best pieces are kept in small storage cabinets. (Courtesy of Emmaline Olson)

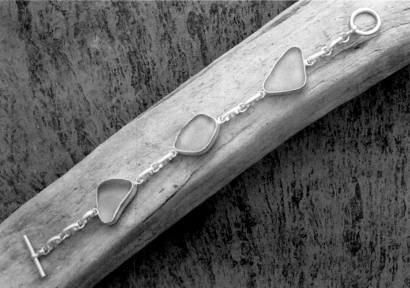

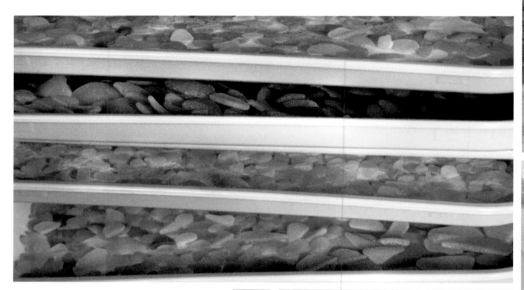

[Right] Cobalt blue, used mostly for medicine containers in the early 1900s, is bezel-set on a choker necklace. A touch of olive oil adds a soft illumination to its surface. (Courtesy of Nancy LaMotte)

[Far right] Throughout the LaMottes' home there are dozens of historic bottles surrounded by matching sea glass. These bottles were used for baking powder, soda, and beer in the early 1900s. This soft blue color, as well as soft green, was very common for such containers at that time. (Courtesy of Emmaline Olson)

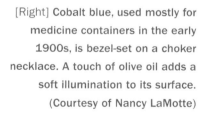

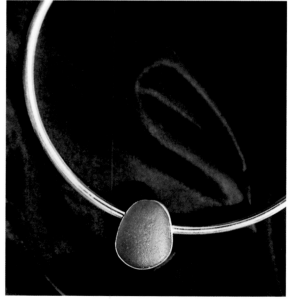

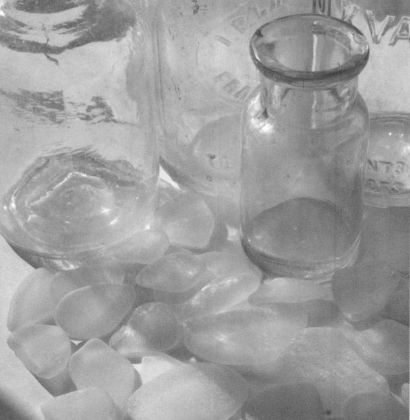

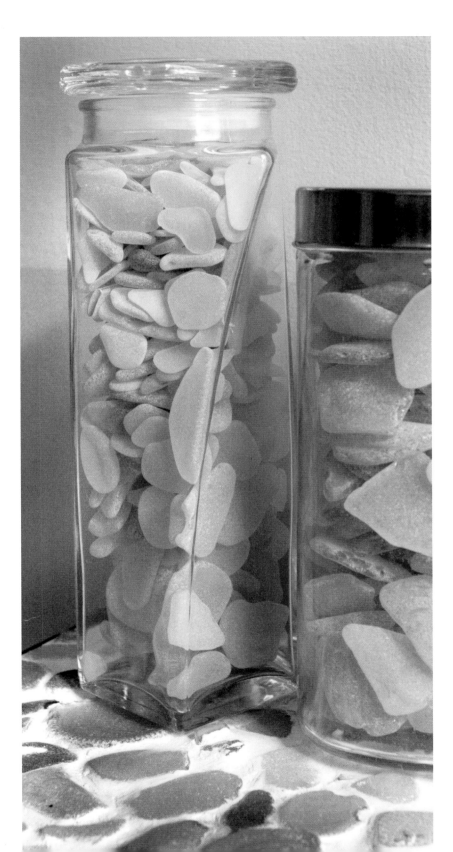

[Left] Jars of sea glass echo the mosaic countertop in the LaMottes' bathroom. Their outdoor shower is also faced with embedded sea glass. "I highly recommend doing bathrooms in sea glass colors, since it will lift your spirits year-round," advises LaMotte. (Courtesy of Emmaline Olson)

[Far right] Light and glass are a wonderful combination. When late-day sun reflects off a nearby pond, it sets up a fascinating dual illumination. (Courtesy of Nancy LaMotte)

ARTISTS & LOCATIONS FEATURED IN THIS BOOK

Alna Goods (Kate Nordstrom): 1690 Alna Road, Alna, ME 04535, tel. 207-586-5048

Arti-Facts (Lynette Walther): Art in the City, 3601 West Alabama, Houston, TX 77027, tel. 713-552-0900; Small Wonder Gallery, Public Landing, Camden, ME 04843, tel. 207-236-6005

Nellie Myrtle Pridgen Beachcomber Museum: 4008 South Virginia Dare Trail, P.O. Drawer Three, Nags Head, NC 27959, tel. 252-441-6259

Beachcomber Studio (Mimi Gregoire Carpenter): P.O. Box 7701, Cape Porpoise, ME 04005, tel. 207-284-7021; www.mimigregoirecarpenter.com; bchcmb@gwi.net; Archipelago, 386 Main St., Rockland, ME 04841, tel. 207-596-0701

Cape Ann Designs (Jacqueline Ganim-DeFalco): www.capeanndesigns.com; Jackie@capeanndesigns.com

Rick Carney: excel@suscom-maine.net

Gnome Homes (Dennis Sheehy): tel. 207-773-0793; www.gnome-home.com; gnomes@maine.rr.com

Lisa Hall Jewelry: P.O. Box 1032, Northeast Harbor, Maine 04662, tel. 207-276-5900; vetrodelmare@aol.com; Archipelago, 386 Main St., Rockland, ME 04841, 207-596-0701

Hooked Rugs by Becky Ford: tel. 603-232-1116

Island Girl Sea Glass (Jane Moran Porter): P.O. Box 112, Little Cranberry Island (Islesford) ME, 04646, tel. 207-460-0301

Kathie Krause: Island Artisans, 99 Main St., Bar Harbor, ME 04609, tel. 207-288-4214, www.islandartisans.com; Winter Works, Box 131, Monhegan Island, ME 04852; Archipelago, 386 Main St., Rockland, ME 04841, tel. 207-596-0701

Richard and Nancy LaMotte: www.pureseaglass.com; www.chesapeakeseaglass.com; tel. 410-778-4999; fax 410-778-4999

Larry Truman: Greenwood Garden, Peaks Island, ME, tel. 207-832-5826; LTPEAKS61@aol.com; Archipelago, 386 Main St., Rockland, ME 04841, tel. 207-596-0701

Amy Wilton Photography: www.amywilton.com

ISBN (13-digit): 978-0-89272-707-0

LIBRARY OF CONGRESS CATALOGING-IN-PUBLICATION DATA

Lambert, C. S. (Carole S.), 1953-
A passion for sea glass / text by C.S. Lambert ; photographs by Amy A. Wilton.—1st ed.
 p. cm.
ISBN 978-0-89272-707-0 (trade hardcover : alk. paper)
1. Glass craft. 2. Sea glass. I. Title.
TT298.L33 2008
748.5—dc22

2008016059

Design by Faith Hague

5 4 3

www.downeast.com
Distributed to the trade by National Book Network